TOMORROW IS A LONG TIME

Tijuana's unchecked HIV/AIDS epidemic

Photos by Malcolm Linton | Text by Jon Cohen

Daylight

Cofounders: Taj Forer and Michael Itkoff
Design: Ursula Damm
Copy editor: Elizabeth Bell
Design Intern: Meg Bosse

This book project was made possible with the generous support of the Ford Foundation's Mexico and Central America office. Other support came from the American Association for the Advancement of Science, the Open Society Foundations, Global Health Strategies, the John D. Evans Foundation, and the Pulitzer Center on Crisis Reporting.

Special Rider Music graciously granted permission to excerpt from Bob Dylan's "Tomorrow Is a Long Time."

ISBN 978-1-942084-08-2

Printed in Colombia

Daylight Books
E-mail: info@daylightbooks.org
Web: www.daylightbooks.org

Photographer Malcolm Linton and writer Jon Cohen have worked together since 1997 covering the HIV/AIDS epidemic in more than 30 countries for *Science* magazine. They launched this project to document the obstacles that stand in the way of ending AIDS and decided to focus on a single place for an extended time. They trace over many months what happens to people who are living with HIV or at high risk of infection. They chose Tijuana because its epidemic has the same drivers that exist in scores of other locations worldwide.

With support from the Ford Foundation, Linton moved to downtown Tijuana in July 2013, and Cohen began making day trips from his home near San Diego. Initially Linton worked as a nurse at Proyecto El Cuete, run by the University of California at San Diego, taking blood from people who inject drugs. They completed their fieldwork in April 2015.

Everyone who participated in this project gave permission for his or her photographs and stories to appear here. The authors hope these vignettes will promote a more informed view of the dilemmas created by HIV/AIDS.

A few minutes' walk from the city's red light district, the Tijuana River Canal runs along Mexico's border with the United States. The water that flows through its center is putrid, and hills of silt, dirt, and trash often form along its banks. About 1,000 people lived in the canal in 2013, many sleeping in makeshift shelters they call *ñongos*.

In this "neighborhood," known as El Bordo, a sluice gate served as a store-front for heroin dealers, and users gathered along the nearby wall.

According to a study done by researchers at Tijuana's Colegio de la Frontera Norte in the summer of 2013, 96% of the canal residents had been arrested by the Tijuana police at least once and 91% were deported from the United States. Studies of specific groups, such as people who inject drugs and sex workers, suggested there was far more HIV in the canal than in the community at large.

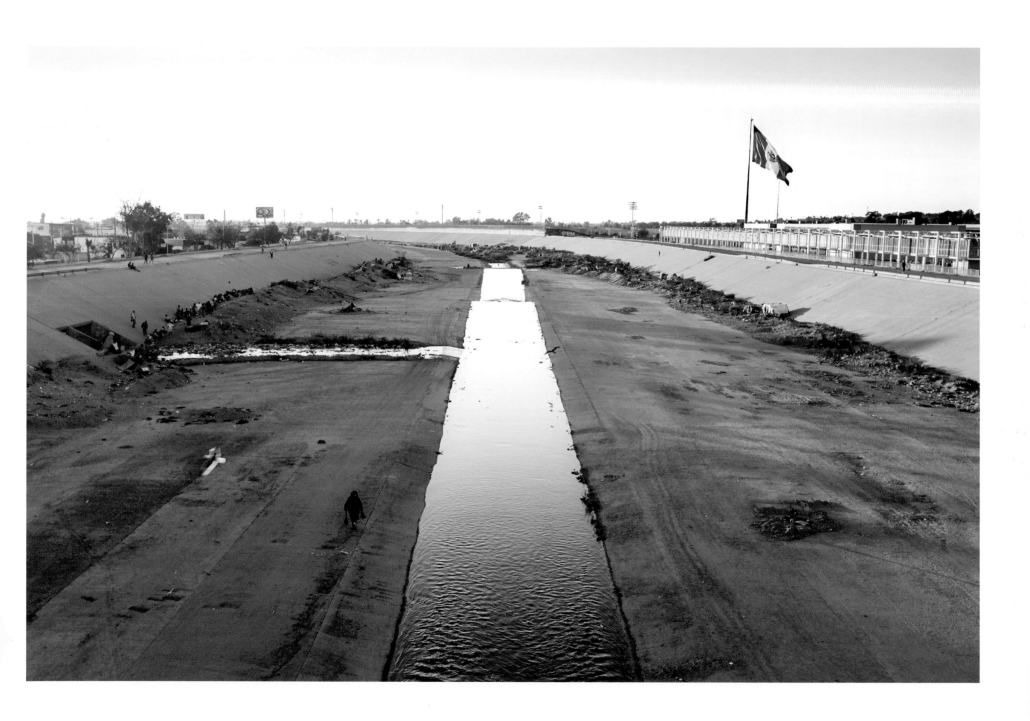

A FRACTURED
RESPONSE TO HIV/AIDS

On December 6, 2013, Pedro Robles spent 14 hours in an ambulance being driven up Mexico's Baja Peninsula. The 51-year-old man was not rushed north for emergency medical care, sirens blaring, cars pulling over to make way. Time was not of the essence.

Pedro Robles began his journey in Loreto, a quaint resort town on the Gulf of California, and ended it 700 miles north at Albergue Las Memorias, an AIDS hospice on the outskirts of Tijuana. The city is a magnet for migrants who dream of a new life in the United States, but Pedro had come to Tijuana, his old home, because Las Memorias held out the slim hope that someone there could navigate the medical bureaucracy and maybe save his life. At the very least, it offered a more dignified place to die.

In wealthy countries such as the United States—which is visible from downtown Tijuana—people with late-stage, untreated AIDS have become a rarity. Not so in Mexico. Despite the development of simple and fast tests to detect HIV, powerful and safe antiretroviral drugs, and ramped-up efforts to combat the disease, Pedro had an advanced case of AIDS, and at Las Memorias he would join others in the same condition.

When Pedro fell ill in Loreto, the woman he was living with sent him packing. A human rights group arranged to shuttle him to Las Memorias because it was the only AIDS hospice on the entire Baja Peninsula. He shared a room there with a dozen people whose immune systems had been erased by the AIDS virus. "I just learned I had HIV two weeks ago," he said on December 10, as he faded in and out of consciousness. A decade typically passes before HIV causes this level of damage.

Las Memorias has no doctors or nurses but the staff did what it could to make Pedro comfortable and arrange the documentation that Mexico requires before providing medical care. As usual, the public medical system in Tijuana moved slowly. On December 12, he was constantly gasping for air, his windpipe rattling and his eyes rolling about aimlessly. He no longer could speak.

A great distance separates the aspiration to end AIDS from the achievement of that goal.

Alfredo Valenzuela stood by the bedside and watched. "We used to rob and play casino and do crystal," he said. According to Alfredo, Pedro lived in Tijuana for years, once even rooming with him at Hotel Caesars on Revolución Avenue, the storied main drag that went quiet a few years back when drug cartel violence scared off U.S. tourists. "He had a lot of girlfriends," said Alfredo. "I got infected the same way."

A few hours later, Pedro Robles had no energy left to breathe.

On World AIDS Day, five days before Pedro Robles arrived at Las Memorias, politicians, public health officials, and deep-pocketed funders made speeches and issued statements that trumpeted optimism. "If we channel our energy and compassion into science-based results, an AIDS-free generation is within our reach," proclaimed U.S. President Barack Obama. The head of the Joint United Nations Programme on HIV/AIDS (UNAIDS), economist Michel Sidibé, declared that the "world is poised to end AIDS."

A few years earlier, such pronouncements would have seemed preposterous, even delusional. But over the preceding five years, human studies had shown that HIV treatment itself could slow the disease's spread, because the drugs reduce the virus to such low levels that people no longer transmit it to others. This is called "treatment as prevention." A handful of other biomedical prevention interventions had proven their worth, too. The power of these new tools, especially when combined with staples such as condom promotion, education, and behavior change, sparked the excitement about ending AIDS, especially in locales that have relatively small epidemics contained in high-risk groups. Tijuana fits that bill. Yet it provides a reality check for many cities around the world that have similar "micro hyperepidemics": A great distance separates the aspiration to end AIDS from the achievement of that goal.

In the United States, Canada, Europe, and Australia, ending AIDS seems reasonable, if hugely challenging. The bad old days of the epidemic are history. AIDS hospices in these wealthy parts of the world have shut their doors. Treatment is offered routinely to everyone who tests positive for the virus. No one with AIDS, not even people suffering from the late-stage disease that Pedro had, needs to ride in an ambulance for 14 hours to receive proper treatment and care.

Only a vaccine, which remains a distant dream after 30 years of research, can eradicate HIV from the human population. But proponents of ending

AIDS have a more modest aim. To retain its epidemic status, AIDS requires that each infected person spread the virus to at least one other. If combinations of prevention interventions can slow transmissions such that, say, only 75% of people infect someone else, an epidemic will sputter and, eventually, stop.

Antiretrovirals can be used not only to treat HIV but also to protect the uninfected if they are given as "pre-exposure prophylaxis," or PrEP. Providing people who inject drugs with clean needles and syringes, as well as opiate substitutes such as methadone, can outwit the virus, too. Male circumcision reduces the risk of infection by about 60%. And tests for HIV have become simpler to administer, faster to yield answers, and more sensitive.

Yet even rich countries are having great difficulty in benefiting from treatment as prevention—the central ingredient in the recipe for ending AIDS epidemics. (See back cover.) The reason is the so-called treatment cascade, a series of obstacles that prevents HIV-infected people from getting care. First they must get tested and know they are infected. Then they must link to qualified caregivers who prescribe the right medicine and run periodic tests to monitor their well-being, which requires money, private insurance, or a government plan. A clinic visit often means taking time off work and

finding transportation. Even if all this falls in place, they still will have their lives cut short if they fail to take their medicine as prescribed because of alcohol and other mind-altering drugs, living on the streets, a perpetually empty stomach, a spell in jail, or confusing voices in their heads.

In 2014 UNAIDS set an "ambitious treatment target to help end the AIDS epidemic," calling the plan 90-90-90: By 2020, 90% of infected people will know their status, 90% of that group will receive antiretrovirals, and 90% of people on treatment will have fully suppressed virus. The same year, New York State and San Francisco laid out their specific plans to end AIDS. But the best available figures in the United States showed that only 30% of HIV-infected people were then on treatment and had undetectable levels of HIV.

Unless they have substantial foreign assistance, cash-strapped governments face a magnified version of the treatment cascade dilemma. And migrant-filled border towns such as Tijuana typically are the poor relations in their own struggling countries.

Hardly anyone notices when someone like Pedro Robles dies of AIDS in a Tijuana hospice, while just across the border in San Diego people are

talking about ending the epidemic. At Las Memorias, Victor Mora had little choice but to watch. Victor, who was 48 years old, occupied an adjacent bed, and HIV had so wrecked his body that he spent most of his days parked on his mattress.

As Pedro took his last breaths, Victor minded his own business, looking past his neighbor to watch TV. Victor showed no emotion at either the program or the man dying in front of him. He had compassion for Pedro but knew he had little chance of receiving the medical care he needed. "I've seen 15 people die here," said Victor.

This was not a criticism of Las Memorias, which in addition to its role as a hospice serves as a drug rehab center and shelter for the homeless infected with HIV. In all, it provides a home to nearly 100 men, women, and children who have nowhere else to turn. "The government is very slow," Victor explained.

He was speaking from experience. When Victor arrived in September 2013, he had a long-standing HIV infection, constant diarrhea, and an emaciated body. It took a month before Las Memorias could arrange for the government's dedicated HIV/AIDS clinic in Tijuana, CAPASITS, to see him.

The doctors drew his blood and flew it 1,400 miles south to a national laboratory in Mexico City to determine whether his HIV had developed drug-resistant mutations. Then they sent him to a local lab that would reveal the level of virus in his blood and how much damage his immune system had endured.

The Mexican government at the time recommended antiretroviral treatment only for sicker people. HIV preferentially infects and destroys white blood cells that have a protein on their surfaces named CD4. The 2012 Mexican guidelines called for treating people who had fewer than 350 CD4 cells per microliter of blood. (Normal is 600 to 1,200.) But the World Health Organization, which issues guidelines for all countries, in June 2013 recommended increasing the cutoff to 500 CD4s, recognizing that earlier treatment benefits both the infected person and the community. Mexico had yet to adopt the new recommendations.

Victor Mora started antiretrovirals on November 29, his CD4 count at 234, nearly three months after he moved into Las Memorias.

This is no way to do treatment as treatment, let alone treatment as prevention.

In 1996 *Newsweek* magazine ran a cover story titled "The End of AIDS?" The question was posed because new antiretroviral drugs, when used in combination as "cocktails," had shown remarkable power against the virus. Until then, AZT and the three other anti-HIV drugs on the market extended life by only a few years. The new antiretroviral cocktails, in contrast, drove down HIV to undetectable levels on standard blood tests, and patients on their deathbeds recovered. *Time* magazine's "Man of the Year," virologist David Ho of the Aaron Diamond AIDS Research Center in New York City, famously calculated that if the cocktails could fully suppress the virus for as little as 2.3 years, HIV might be eradicated from the body.

As it turned out, the calculation was wide of the mark: It did not account for the existence of hard-to-detect reservoirs of latent HIV. Stitched inside human chromosomes, the virus's DNA can lie quiet for decades, impervious to antiretrovirals and immune attack. An authoritative study that factored in the reservoir to Ho's calculations concluded it would take 73 years of fully suppressing the virus with drugs to clear an infection.

A landmark study in Vancouver, Canada, that also first received attention in 1996 underscored how premature it was to talk about the end of AIDS.

In a community of people in downtown Vancouver who injected drugs, epidemiologist Steffanie Strathdee and co-workers at the University of British Columbia found 18.6% each year converted from HIV negative to positive—the highest incidence seen in any developed country. "There were so many seroconversions in that study that I had to get counseling for my staff," said Strathdee. The epidemic was exploding, undetected, in a country that had resources and a top-notch public health system.

Marriage to psychologist Tom Patterson in 2004 led Strathdee to accept an appointment at his institution, the University of California at San Diego (UCSD), and they began collaborating. Patterson was developing a program for women who sold sex in Tijuana that aimed to reduce their risk of becoming infected by HIV and other sexually transmitted diseases. Strathdee soon branched out, launching a project dubbed El Cuete, or the rocket, street slang that referred both to getting high and to the shape of the syringe and needle.

Strathdee and Patterson built a binational team with Mexican doctors, nurses, counselors, health officials, and outreach workers that has clarified the contours of the Tijuana epidemic. Their research documents how the virus has concentrated in sex workers, people who inject

"Are we crying wolf? Maybe. You know what? I'm going to take the risk."

drugs, men who have sex with men (MSM), and transgenders. Tijuana doctor Patricia González runs El Cuete's office and, in 2014, began staging a mobile clinic in the Tijuana River Canal. Susi Leal is El Cuete's key outreach worker, tracking the project's participants, who frequently forget their test appointments, change addresses, or get put in jail. A former heroin user who is HIV-positive herself, Leal lived in the canal off and on for eight years. José Luis Burgos, another doctor from Tijuana, oversees a free Saturday clinic called Health Frontiers in Tijuana that is staffed by medical students from UCSD and their counterparts at the Universidad Autónoma de Baja California. Graduate students work on advanced degrees studying everything from transgenders to police interactions with drug users.

All told, by 2015 Strathdee and Patterson had published more than 100 scientific reports together. Their work soon became intertwined, as people who inject drugs include MSM as well as sex workers, their clients, and their regular partners. "You start to see overlapping populations and how the risk behaviors begin to interact with one another," said Patterson. "You can't just intervene on one subset of people or focus on one type of risk behavior, whether it's sex or drugs. You need to be thinking of all these things simultaneously."

The people that Strathdee and Patterson study often have complicated life stories, and many details are difficult to verify. From one perspective, the tales they tell are their own version of truth: This is how they want others to see them and their world. But the UCSD group has used blood samples and carefully structured interviews to move beyond anecdote and into science.

Strathdee and Patterson's research has spotlighted the haphazard response, and the potential for AIDS not to end but to explode as never before. And they are trying to get both Mexico and the United States to pay attention to what they see as a regional problem. "I wish that in Vancouver, at the time I was seeing the risk behaviors that I'm seeing in Tijuana, I had screamed a little louder, because maybe I could have prevented an epidemic," said Strathdee. "Are we crying wolf? Maybe. You know what? I'm going to take the risk."

Mexico does not have a severe HIV/AIDS epidemic—especially considering its other health problems. UNAIDS estimated in 2013 that of the country's 122 million people, only 180,000 were living with HIV, an adult prevalence of 0.2%. (In comparison, adult HIV prevalence that year was 0.5% in the United States and 19.1% in South Africa.) But the UCSD researchers have shown that the prevalence in Tijuana is three times higher than in Mexico overall—and

they have documented far more disease in risk groups that had never been carefully studied. Their research also repeatedly emphasizes the binational aspect of the epidemic. Tijuana is the busiest land border crossing in the Western Hemisphere, with 50,000 vehicles and 25,000 pedestrians entering the United States each day. After the 9/11 attacks, the U.S. government increased the movement of people in the other direction, massively stepping up deportations of Mexicans illegally living in the United States. "The bugs don't recognize the border," said Strathdee.

Strathdee and Patterson have shown that HIV prevalence in women who sold sex jumped from 2% in 2003 to 6% by 2012. Clients of these sex workers, half of whom came from the United States, had a prevalence of 5% themselves. In sex workers who had active cases of syphilis, which eases HIV's spread, prevalence soared to 12%.

An estimated 10,000 people in Tijuana inject heroin or other drugs, the largest number per capita of any Mexican city. Many of them do not have a steady job or even a home, making them a difficult group to follow. But El Cuete has captured elusive data about how HIV is moving through this population and about the factors driving the spread. In addition to taking blood from participants every six months and testing them for

HIV and hepatitis C, El Cuete's team interviews users about their lifestyles, maps where they inject, and assesses the impact of drug policy reforms on infection rates.

Women in the ongoing El Cuete study have an HIV prevalence of 10.2%, which is three times higher than men's. This discrepancy is in part because women more frequently have syphilis. Men who are deported to Tijuana and are later tested for HIV are four times more likely to be infected. In interviews conducted in 2014, 42% of both men and women said they recently had shot up with someone else's needle and syringe.

Some 95% of people who inject drugs in Tijuana also have the hepatitis C virus, which is spread through contaminated needles more easily than HIV and better indicates how frequently sharing occurs. Across the border in San Diego, hepatitis C has infected only 27% of drug users. In 2014, Tijuana had three clinics that offered methadone maintenance, an effective therapy to help people stop using heroin; the clinics all charged for methadone, and a mere 7.5% of the opiate users interviewed had tried it.

A Mexican law instituted in 2010 makes it legal to possess small amounts of many illicit drugs, including heroin. Pharmacies are allowed to sell

needles and syringes without a prescription, but many refuse to do so. Users report that police regularly confiscate or break their needles. In one study, nearly 50% said they had been arrested simply for having unused syringes in their possession, and the UCSD researchers linked this to a two-fold increase in sharing, presumably because people became wary of carrying them. In 2014 the UCSD group launched an HIV/AIDS training program for police about the new drug laws and about ways to protect themselves from on-the-job needle stick injuries. The program ultimately aims to reduce needle sharing and HIV risk among drug users by making them less subject to harassment for carrying their own syringes.

The groups at the highest risk of becoming infected with HIV are male-to-female transgenders and MSM. Small studies by the UCSD team in 2012 suggest the HIV prevalence in both groups is around 20%. In 2014 Patterson launched the first large survey ever done in Tijuana of HIV infection in MSM, and preliminary data find that 88% of those who test positive for the virus do not know they are infected.

An analysis done in 2014, pooling data from six studies, looked at nearly 200 HIV-infected people in Tijuana, yielding the first treatment cascade data for the city. Of the people included in the studies, 52% had never before had an HIV test. Only 11% of the infected people were receiving professional health care and fewer than 4% were taking antiretroviral drugs.

Certainly the situation in Tijuana is improving. A decade ago hardly anyone received antiretrovirals. Today antiretrovirals are, theoretically at least, freely available at the CAPASITS HIV/AIDS clinic. New guidelines issued in November 2014 recommend that antiretrovirals be offered to all HIV-infected people, regardless of CD4 count. With help from the Global Fund to Fight AIDS, Tuberculosis and Malaria, Tijuana also launched an aggressive needle and syringe exchange program run by two nongovernmental organizations that specialize in HIV/AIDS, Prevencasa and SER (Centro de Servicios).

Yet the response in 2015 remained fractured in many ways. No coordinated, aggressive testing program existed. Tijuana's needle and syringe exchange program largely fell apart at the end of 2013 when the improving Mexican economy made it ineligible to continue receiving support from the Global Fund. Most pharmacies still refused to sell syringes to drug users. CAPASITS was located far from the center of Tijuana, and it could not treat many deportees because they did not have documentation to prove they were Mexican. CAPASITS still sent blood samples to other labs because it could not do the tests itself, and

it relied on old-fashioned tests for tuberculosis, a disease that is difficult to diagnose in HIV-infected people and is a leading cause of AIDS deaths. For people who started antiretrovirals, no organized team of outreach workers existed to help them stay on treatment.

José Luis Burgos said Tijuana must make it simpler for HIV-infected patients to see qualified doctors, adding that primary care physicians all over the city could receive the necessary training. "You need to demystify HIV care," Burgos said.

Strathdee remained hopeful that the situation would improve. "It's entirely possible to end the AIDS epidemic in Tijuana," she said. "But when you get right down to it, what we really need is political will, resources, binational cooperation, and to look at the gaps."

No one claimed the body of Pedro Robles, who died of AIDS on December 12, 2013. A month later, a van from the city morgue took him to Panteón Municipal #12, a cemetery for paupers in the middle of the desert, halfway between Tijuana and the neighboring city of Tecate.

A private cemetery, Puerta del Edén, sits on the hills overshadowing Panteón Municipal #12. At Edén, the deceased arrive in hearses that have motorcycle police escorts in front and long lines of mourners driving behind. Elaborate coffins are lowered into the ground during a service attended by loved ones. Engraved marble tombstones decorate covered graves.

None of that happens at Panteón Municipal #12. Pedro Robles was buried in a particleboard box labeled 63, carried to a deep ditch by workers wearing latex gloves who had never met him. The workers placed his coffin on top of five identical boxes. A bulldozer covered the grave with dirt. The workers from the city morgue got back in their van and drove past the many wreath-adorned crosses at Puerta del Edén, stopping at a spigot near its entrance to wash their hands.

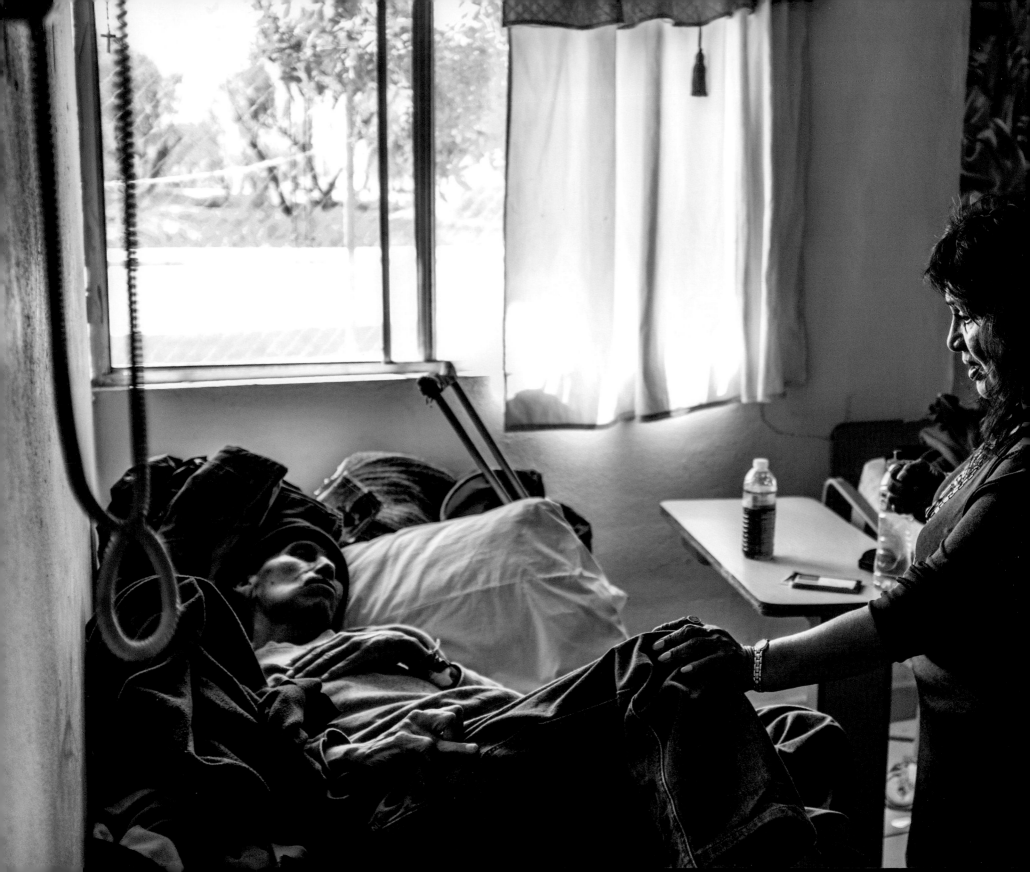

They knew each other from the Tijuana River Canal

Susi Leal occasionally visited Las Memorias, an AIDS hospice in Tijuana that she once called home. An outreach worker for an HIV-related research project, Susi met Victor Mora there in September 2013. They knew each other from the Tijuana River Canal, a place where Susi often looked for people who participated in the El Cuete project, which is run by the University of California at San Diego (UCSD). Victor lived in the canal's El Bordo neighborhood from time to time—which he hated. "For me, El Bordo is for people that lost hope," said Victor. "It is a place where you can go down, where you go to die."

Victor learned he was HIV positive in 2005, when he sought treatment for an infection in his penis. By the time he checked into Las Memorias, his immune system had endured so much damage from the AIDS virus that he knew the disease would kill him if he did not receive medical care. But now he had to wait for the government-run HIV/AIDS clinic, CAPASITS, to determine whether he was eligible for antiretroviral drugs.

Susi too is infected with HIV and, like Victor, turned to Las Memorias when she was in bad shape. She credited the hospice with helping to save her life. With Victor, it was unclear whether he would outlive his stay.

Victor grew up in Hermosillo, a city in Sonora state that is a 14-hour bus ride from Tijuana. He moved to the United States at 17, living there on and off on for 27 years. "I really don't feel Mexican," he said.

Victor repeatedly wound up behind bars for everything from drugs to domestic violence to armed robbery, and said he was deported "at least 20 times." Alcohol, sniffing gold paint—which has especially high levels of toluene, an intoxicant—and crack cocaine all worsened his ever mounting health problems. He is deeply remorseful about his past, especially the years he spent in Nogales, Arizona, and the nearby Mexican city of Santa Cruz. He often lived on the bank of a river that crossed the border and specialized in mugging migrants as they tried to sneak into the United States.

"My last wish is to go back to Sonora," he said. "I don't want to die here."

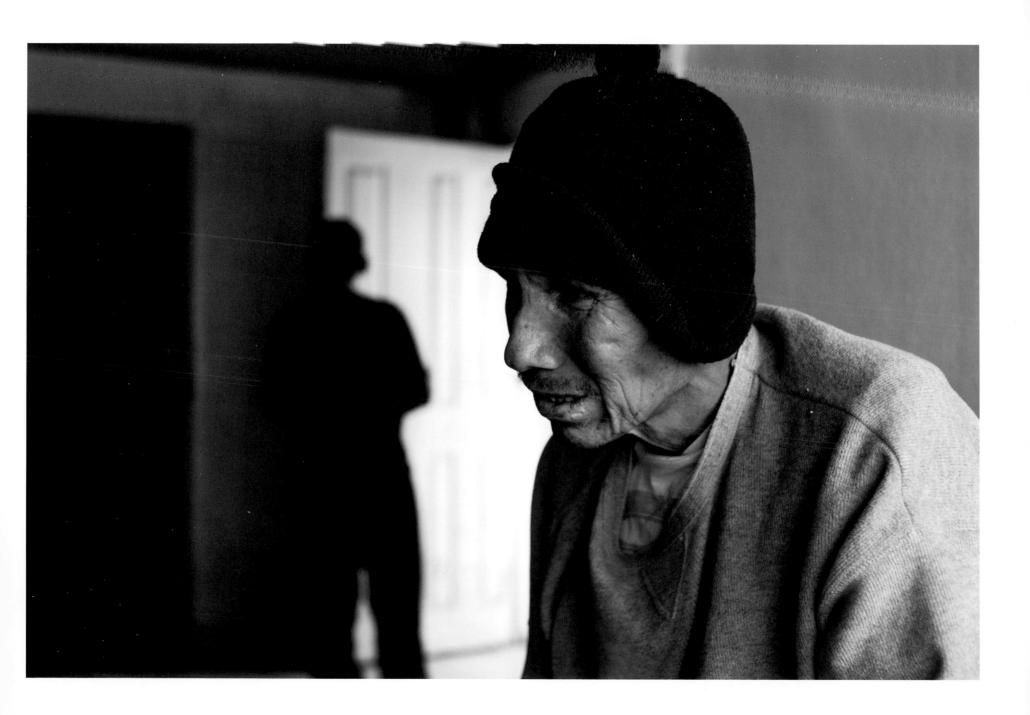

"When people arrive here, it's sometimes hard for them to accept that they're infected."

Disgusted by relentless lice attacks in El Bordo, Victor spent much of his time in Rosarito, a touristy beach town south of Tijuana. He built a make-shift shelter called a *ñongo* in the shadow of the town's icon, the Rosarito Beach Hotel. Eating from garbage cans and constantly battling diarrhea, he thought he had reached the end.

"I never felt before like I was feeling about a month ago," he said in September 2013. He approached a group of Christians making hot dogs on the beach, who offered him food and their prayers, and then took him to a church rehab center that eventually shuttled him to Las Memorias. "I don't want to go to the hell, and I'm trying very hard to change my thoughts," he said. "I don't want to be the same person that I used to be."

Victor did not socialize much. "If I don't see a lot of people, I like that. I'm very, very difficult because I've been living outside always." But when Pedro Robles was put in the bed next to him, they struck up a friendship. "When people arrive here, it's sometimes hard for them to accept that they're infected," said Victor. "He told me he hated to die."

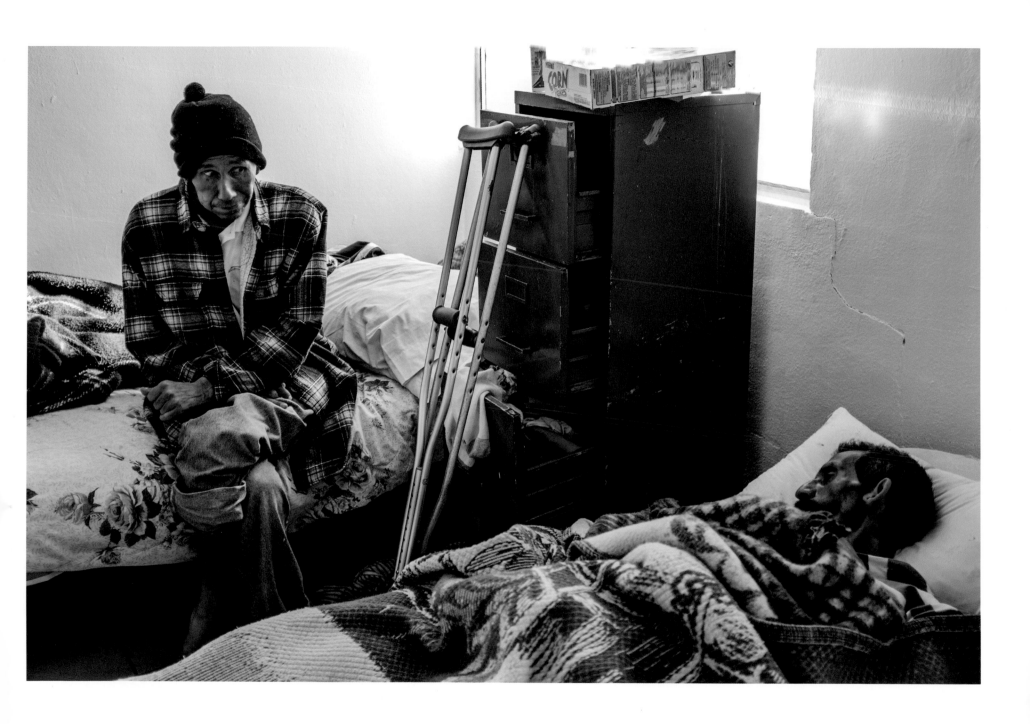

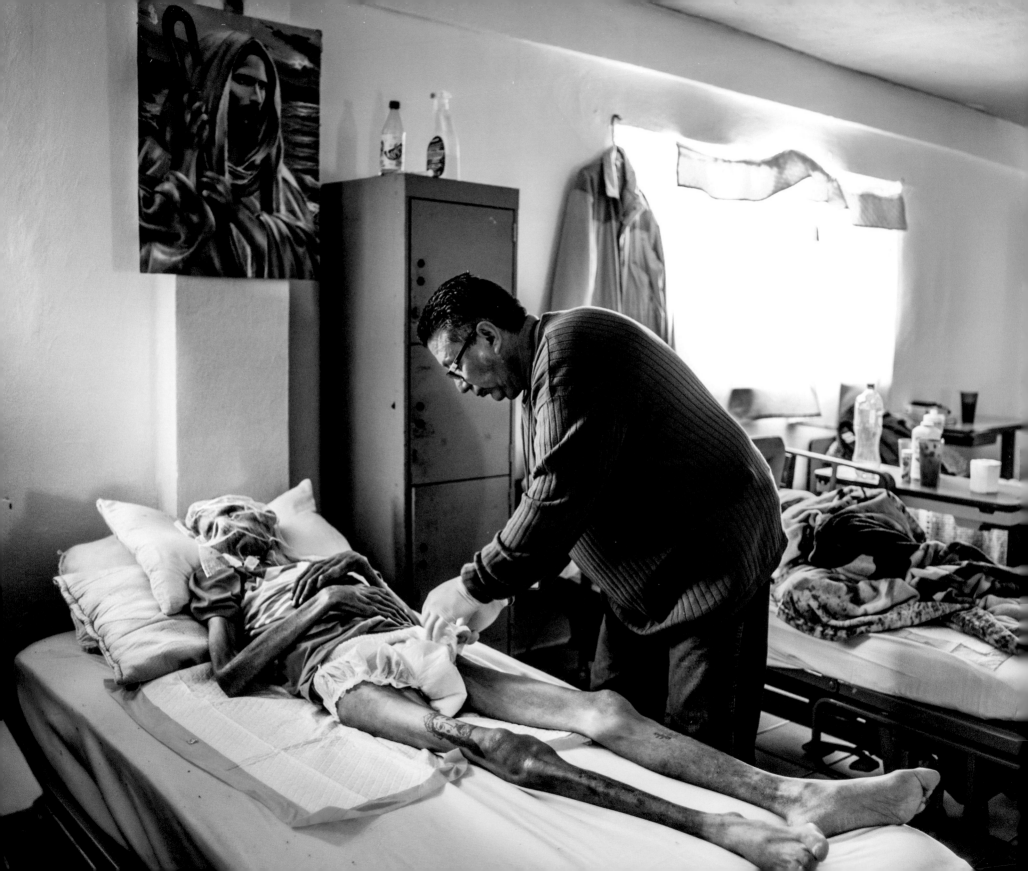

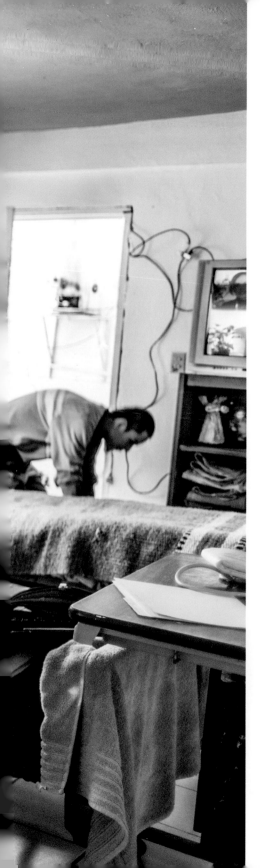

Pedro did not have the strength to brush flies off his face.

Pedro deteriorated quickly, and six days after moving into Las Memorias he did not have the strength to brush flies off his face. Sergio Borrego, who helps run the hospice, put a net over his head.

Doctors and nurses occasionally visit Las Memorias. But for the most part, Sergio said, "I'm the nurse and the doctor."

When Pedro arrived, Sergio guessed that he would only survive one month. Now it looked as if he would not make it through the night.

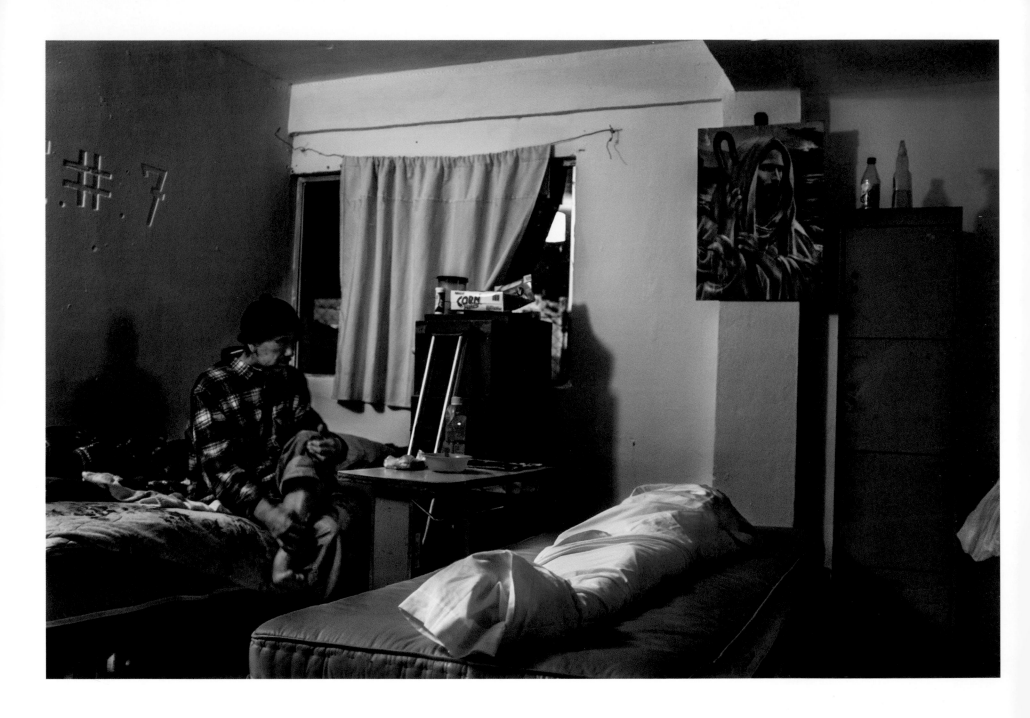

Pedro's chest and throat filled with fluids, and he began making what is known as the death rattle. Then he stopped breathing. Sergio took a stethoscope to his heart and confirmed it was no longer beating. He and two helpers gently wrapped the body in a bedsheet. It took several hours for the city morgue workers to arrive and cart Pedro away. Victor tried to distract himself by watching TV.

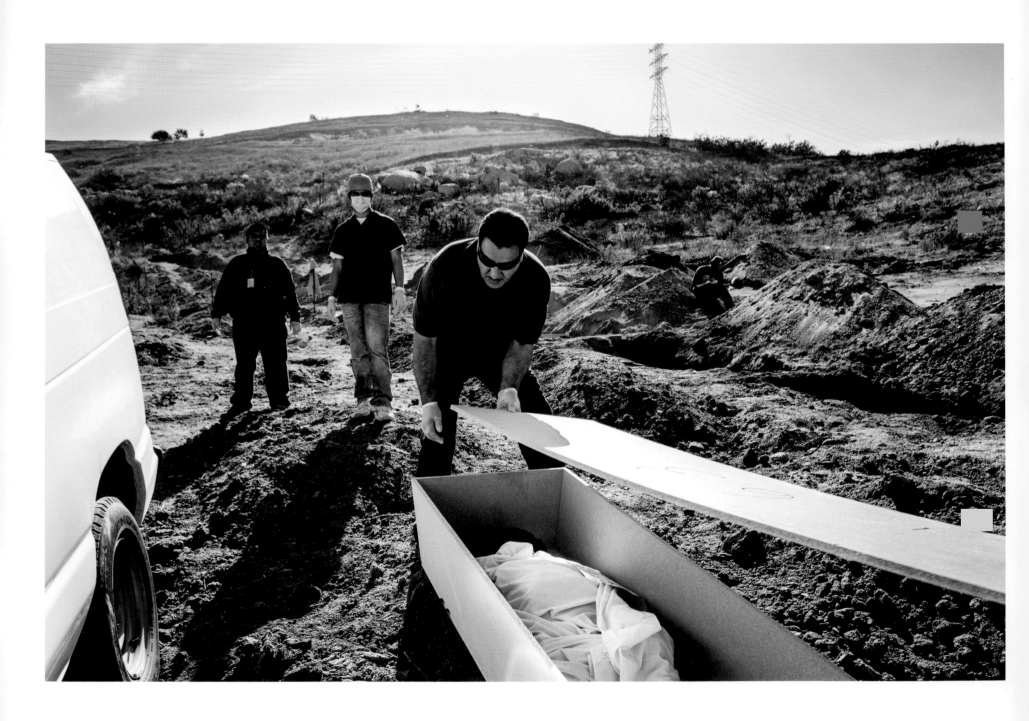

He had become a number, placed in coffin 63.

No one claimed Pedro's body at the morgue. On January 8, nearly a month after his death—the morgue stopped doing burials over the Christmas holidays—he had become a number, 130028246, and was placed in coffin 63 and taken to Panteón Municipal #12, a cemetery on the easternmost edge of Tijuana.

Pedro's particleboard coffin was stacked on top of five others that also had unclaimed dead people inside. "Six people in one hole—that's fucked up," said his friend Alfredo Valenzuela, who watched the burial. "When these people have no money, they just put them in there like that." As a bulldozer dumped dirt over the graves, Alfredo said a prayer for his friend.

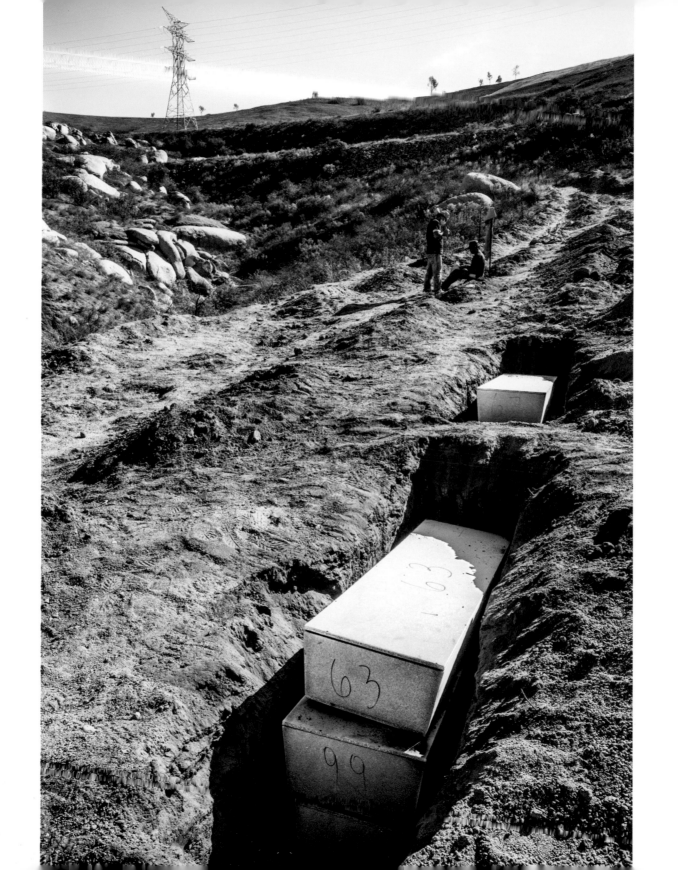

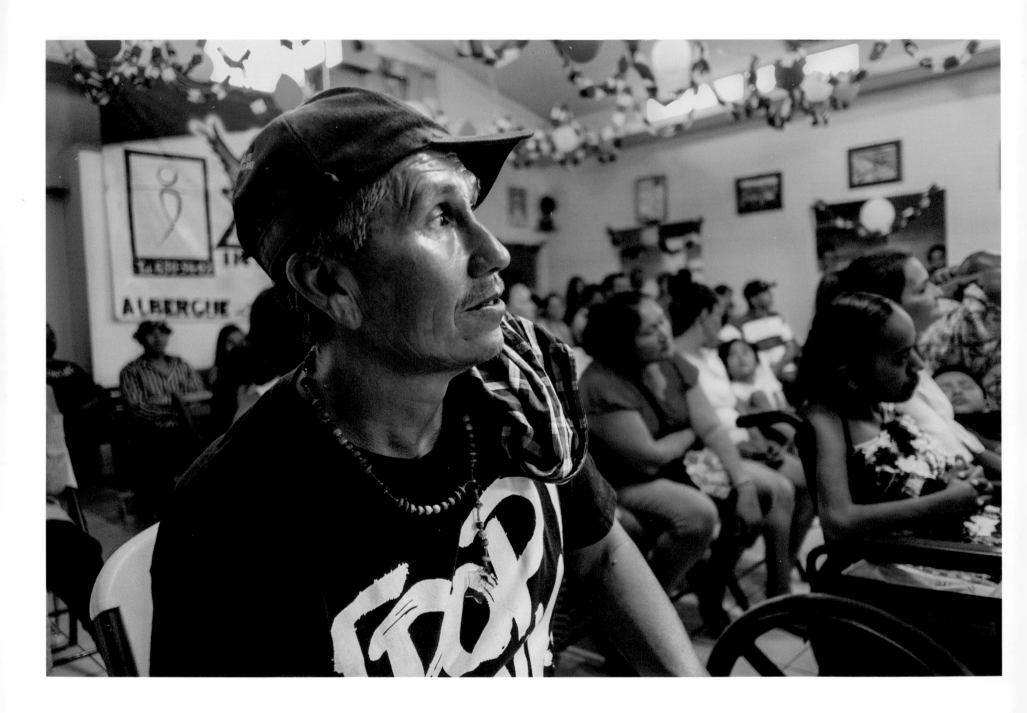

Victor's health rebounded soon after he began to receive antiretrovirals at the end of November 2013. Four months later, he had regained enough strength to leave Las Memorias and moved back to El Bordo. "I had to go there because I ain't got no options," he said. The police soon arrested him. "They didn't even check me, they just put me in the car." In the courtroom, Victor told the judge that he had HIV and showed his Truvada and Kaletra pills. The judge released him.

In June, Victor left El Bordo. "I got like, I'm tired of this, I don't want to see no more drug addicts or Tijuana police. I'm like, Fuck it. I walked from El Bordo to Rosarito." The distance is about 20 miles. It took him two days.

He stayed in Rosarito until September and then rode public transport back to Tijuana because he had an appointment at CAPASITS to refill his antiretrovirals. He first stopped by Las Memorias for a meal and was invited to stay a few days and join their anniversary party.

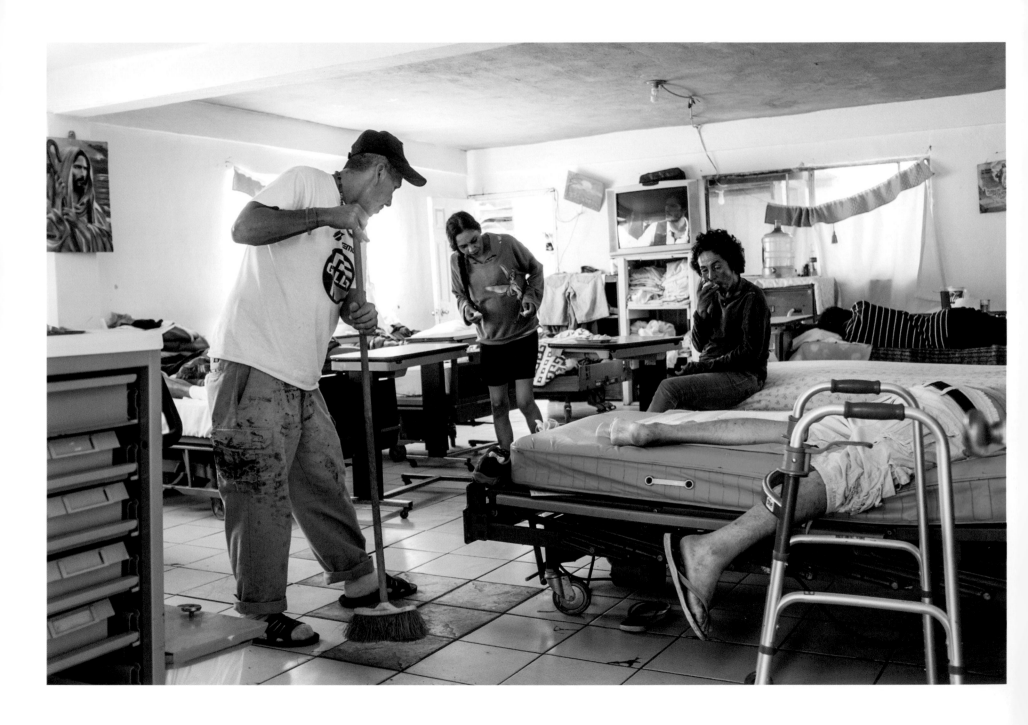

"I feel like I owe this place."

The party came and went, and Victor decided to move in for a while to help. "I feel like I owe this place. I have to do something so I can pay part of what I've been receiving."

During Victor's previous stay, he watched 18 people die. "I counted," he said, adding that he was "sincerely, 100% sure" he would not make it out alive himself. "I wasn't hungry. I had diarrhea with blood. I was so scared."

When Victor was at his sickest, he weighed 61 kilos (135 pounds), and now he was up to 88 (194). "That's a big difference, right, 27 kilos?" He felt supremely lucky that he had survived and regained his strength. "I can't even believe it sometimes. Every day I get up and do anything people ask me."

Victor had had his fill of indoor living.

By the end of fall 2014, Victor had become uncomfortable with indoor living and headed back to Rosarito Beach. A few days before Christmas, he visited the Sisters of Mercy there, and they gave him 200 pesos (about US$14) to pay for a van ride back to Tijuana to pick up another month's supply of antiretro virals. A grassy bank at a highway junction near El Bordo became home again.

Victor still badly wanted to visit his childhood home in Sonora. "I'm going back to Hermosillo, no matter what. I want to see my kids, I want to see my sister, I want to see my friends, and I want to see my city. I want to see the place where I grew up and I was born. I want to spend at least a couple of weeks. They have a CAPASITS there. If I can get a job, I can spend a couple of years."

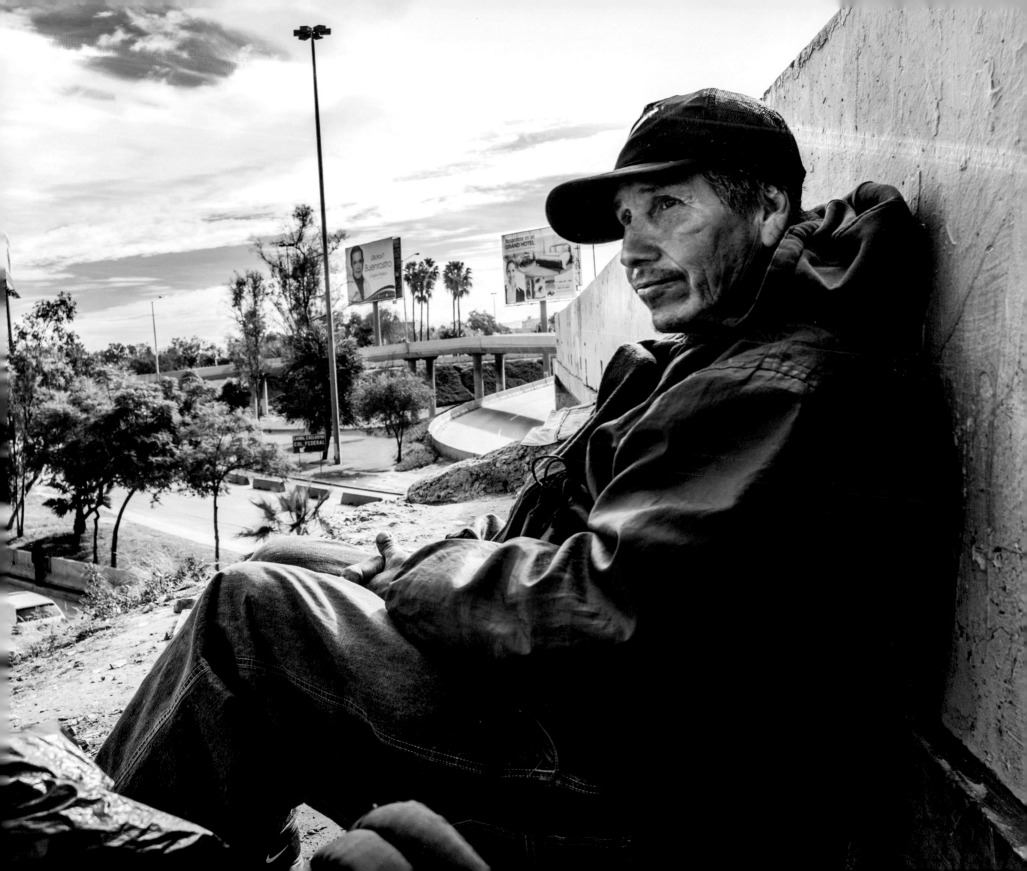

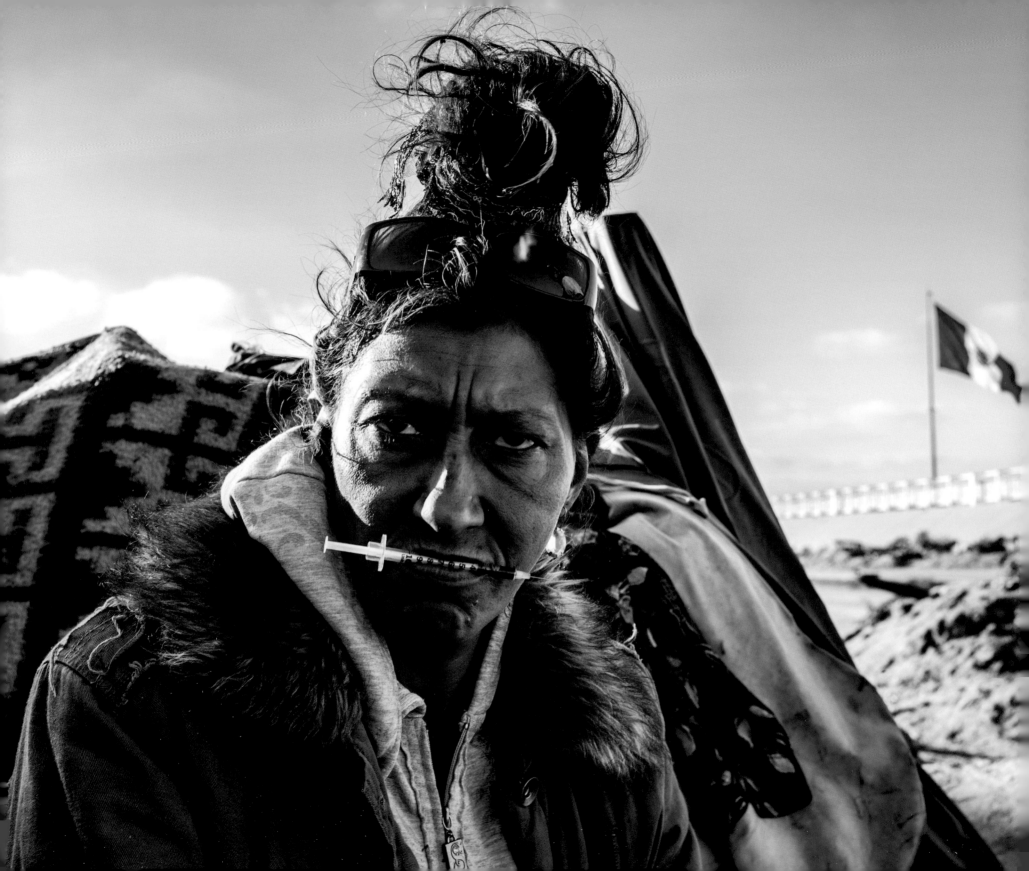

"Even though I'm not originally from the USA, I felt like I was from the USA. My whole life was robbed."

Reyna Ortiz grew up in Southern California and dreamed of joining the police. "I think it's a very beautiful career, but I ended up using drugs," she said. "That's what messed up my life."

Born in Michoacán in 1968, Reyna was taken by her parents to San Pedro, a suburb of Los Angeles, when she was a year old. She was a cheerleader in high school but dropped out to take menial jobs and help her mother with the other five children. "There were days we didn't eat," she said. She started using heroin in her teens, and at 23 she did a six-month prison stint for robbery. "I didn't even know that women would go to jail—that's how naïve I was." Another bust at 28—at which point she had four children herself—led to a three-year sentence and, when it ended, deportation to Tijuana. She had never been to Mexico. "I didn't know nothing about TJ. Even though I'm not originally from the USA, I felt like I was from the USA. My whole life was robbed."

Reyna snuck back into the United States, eventually finding work as a clinical nurse associate at a center for the elderly. She gave birth to her fifth child, but then another arrest led to a second deportation to Tijuana. When the U.S. government stepped up border security after 9/11, she did not even consider trying to return and settled in El Bordo. "We shouldn't live like this," she said. "Not even an animal deserves this. It's wrong. It's bad. But hey, we brought this on. We came here, right? We did this to ourselves."

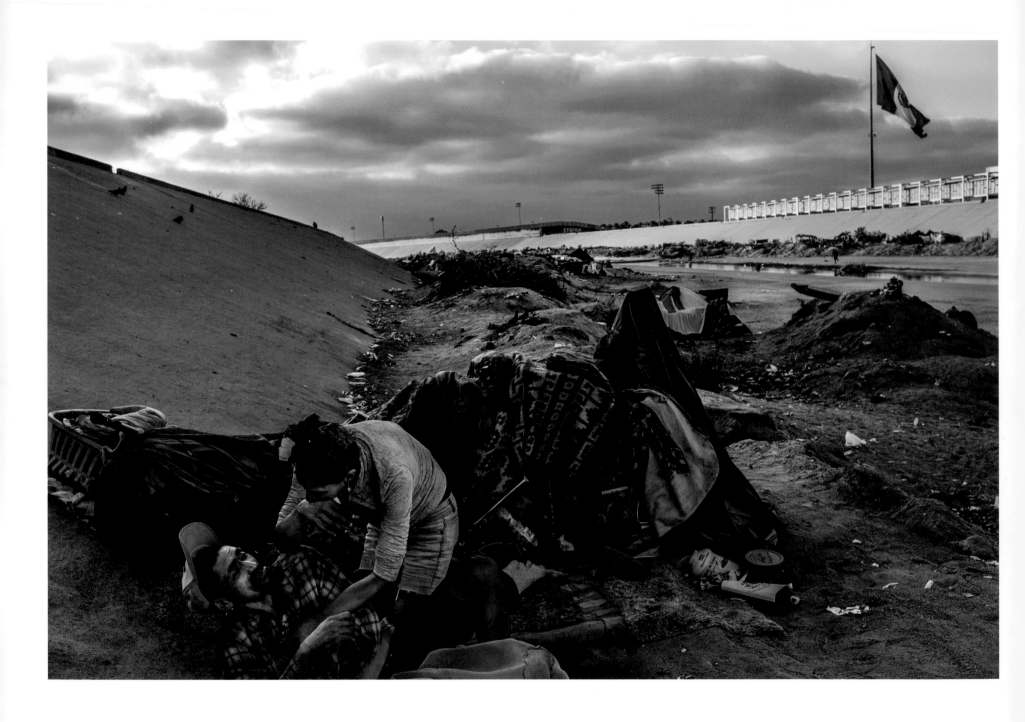

Reyna fell in love with Israel, a former pastor who now lived in El Bordo. He liked to combine heroin and crystal, a potent mix that often left him dysfunctional. Reyna was tender with him. "Isra doesn't take care of himself," she said. Isra in turn took care of Reyna, protecting her from other men and providing drugs and food so she didn't feel compelled to sell sex. "He tells me, 'Oh no, you do not sell your body for drugs. I'll go out and clean cars.' He has a good heart."

The last time she was locked up in the United States, Reyna had an HIV test and it came back negative. She had never taken one in Tijuana. She insisted she never shared needles, even with Isra, and said she injected into her muscles rather than veins, which allowed her to re-use the same "outfit" many times. "I muscle 'cause I just don't like all that blood. It grosses me out."

Reyna said she did have unprotected sex with Isra. "That worries me a lot. A lot, a lot, a lot."

"He was rocking himself for two hours," Reyna said about this man, who died of an apparent overdose. "He was really, really loaded, but he was talking and he had his eyes open." Neither Reyna nor Isra knew his name, but they said a few weeks earlier he had been hit by a car, which frequently happens to people crossing the highway between the canal and downtown Tijuana. He died the day he was released from the hospital. Heroin addicts develop a tolerance, so overdoses can easily happen when people stop using regularly and then start again. In San Diego, police in 2014 joined several other U.S. cities and started to carry a nasal spray that contains naloxone, an antidote to opiate overdose. Tijuana in 2015 still had no such program.

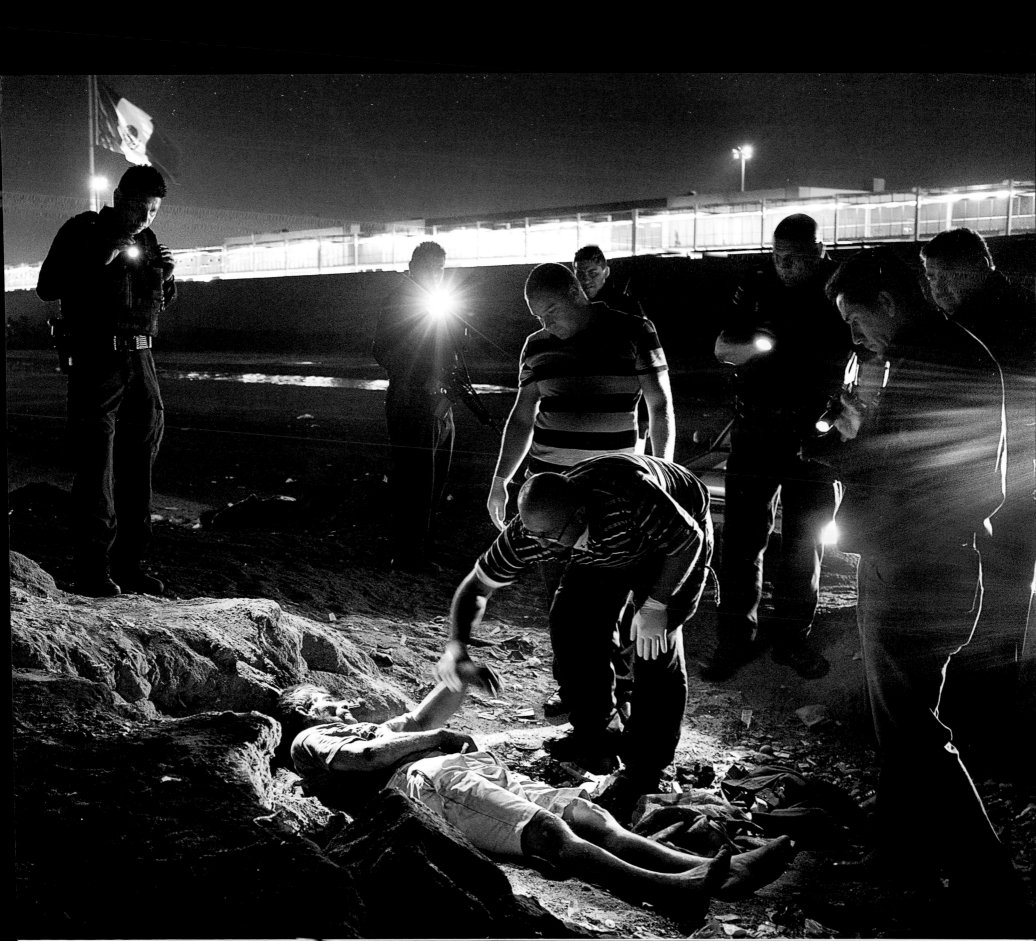

"If there aren't syringes, we go ahead and share."

Christian missionaries frequently visit the canal to bless people addicted to heroin, such as Salome Quintero, a 43-year-old heroin user who lived in this manhole with four others. Salome became addicted to heroin in his twenties and had been to rehab six times. Almost every day, he injected with a syringe already used by someone else. "If there aren't syringes, we go ahead and share," he said.

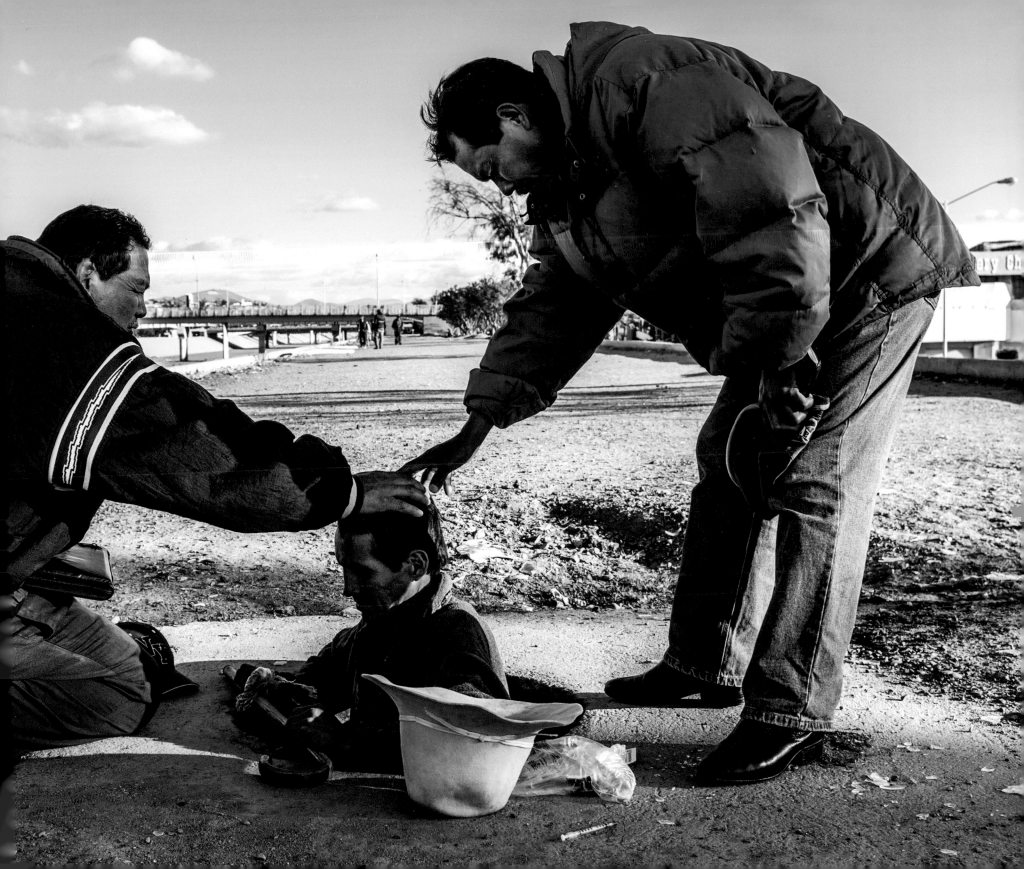

In January 2014, Cosme Caudras and a colleague from Prevencasa, a free clinic near El Bordo, handed condoms and five syringes to each person who came up to their van at a section of the canal known as Los Alamos.

For the preceding three years, Prevencasa's mobile program had been giving out 60 syringes per person, a month's worth, and the van made several stops along an eight-mile stretch of the canal. But Prevencasa's needle and syringe exchange program depended largely on support from the Global Fund to Fight AIDS, Tuberculosis and Malaria, which ended in December 2013 because Mexico's rising economic status had made it ineligible. By design, the Global Fund started projects that, if successful, governments were supposed to continue funding themselves. That did not happen in Tijuana. As a result, Prevencasa cut its mobile program from six days a week, 1,500 syringes per outing, to one day with 750 distributed—and it bypassed the crowd at El Bordo, the most populated section of the canal. SER (Centro de Servicios), another nongovernmental organization, stopped its mobile program altogether, and offered exchanges only at its office, three days a week, which required cutting staff from 12 to two.

El Cuete's preliminary data in early 2015 showed that sharing recently had increased by 40%.

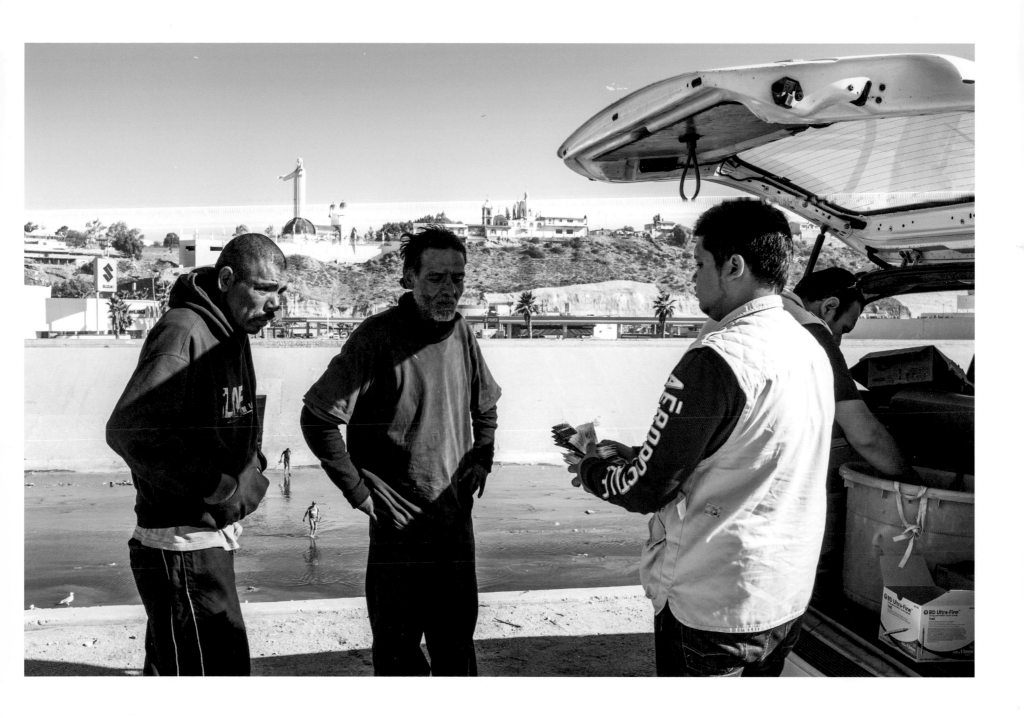

Dr. Patricia González (sitting, at right) set up a Friday first-aid clinic in the canal in July 2014. González, El Cuete's local director, was frustrated that so many of the participants came to her downtown office with untreated abscesses. In the canal, she and her staff cleaned wounds, performed HIV tests, and distributed condoms. They also referred people to better-equipped clinics such as Prevencasa, which provides space for a Saturday program called Health Frontiers in Tijuana, run by medical students.

González's team stayed for three hours and typically treated about 30 people. They parked their van under a highway bridge that had piles of feces at the base of each of its pillars. "You get used to this smell," said González. "It's your environment, so you don't notice."

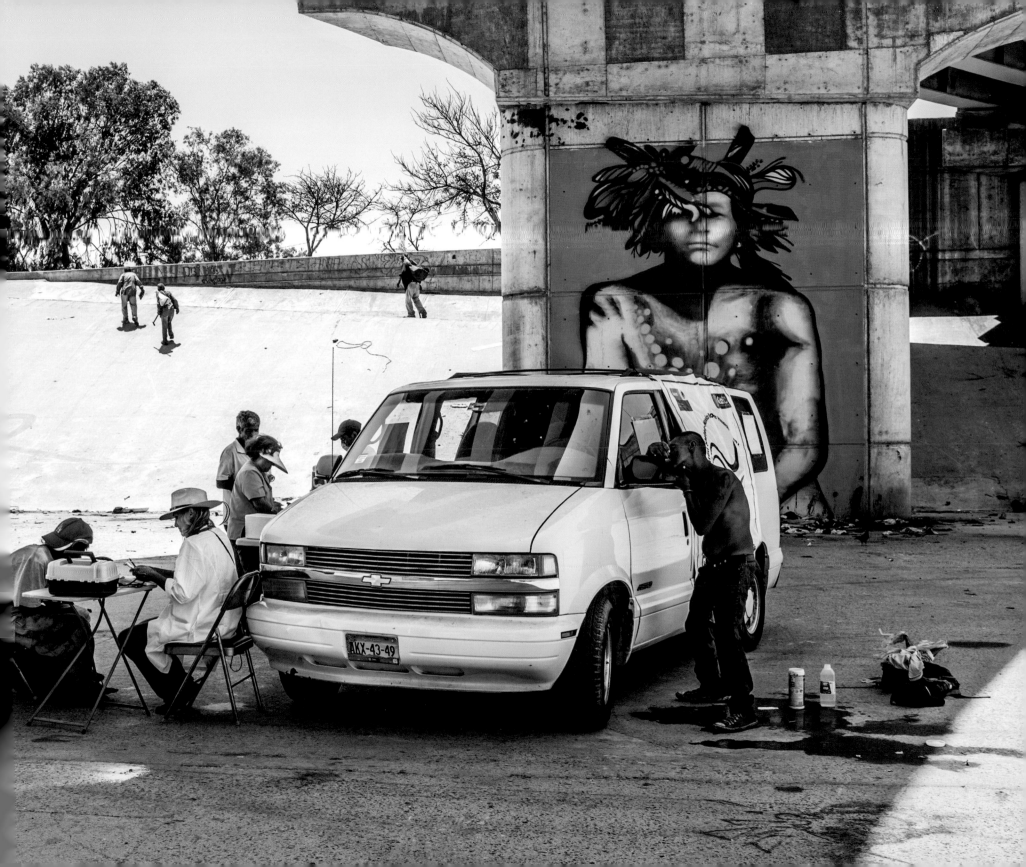

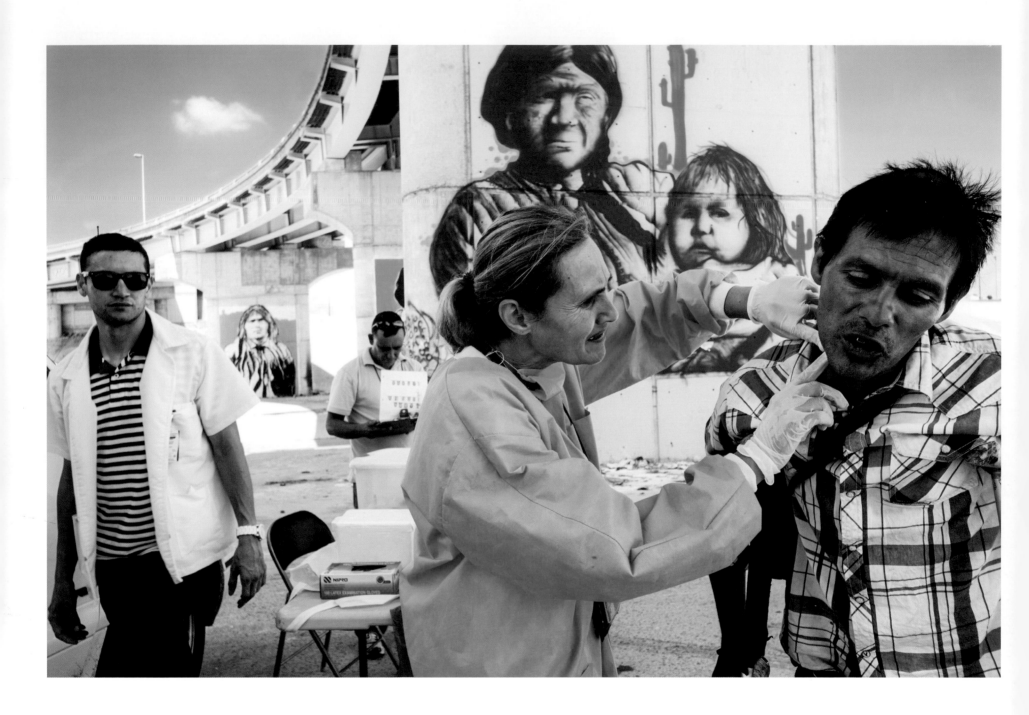

*"If you send someone from the canal to
Tijuana General, they wait to be seen forever —
it's like Stations of the Cross."*

Abscesses typically develop in the arms and legs, but many longtime heroin users blow out veins in their limbs and have to resort to injecting into their necks. Aside from wound cleaning, medical care at the canal clinic was largely limited to rehydration solutions to treat diarrhea.

González grew up in Tijuana and lives close to the canal. She said many people she treated avoided nearby Tijuana General Hospital, where she once worked. "If you send someone from the canal to Tijuana General, they wait to be seen forever—it's like Stations of the Cross." Many also were afraid of the doctors. "They say if they go there, they will not take care of them, or they will cut off their legs or their arms. It's the wrong perception, but that's a barrier, and we need to work with them to start trusting doctors again."

Of the 388 new HIV patients treated at Tijuana General Hospital in 2013, 82 died. All but three were first seen in the emergency room. "A lot of people criticize Tijuana General," said Samuel Navarro, the hospital's chief epidemiologist and head of its HIV/AIDS clinic. Many people failed to understand the challenges the hospital faced, he said. "Patients come to us very sick. The big issue is late diagnosis."

Susi has not used heroin since 2001, and her HIV levels have been undetectable since 2005.

With the help of AFABI (Agencia Familiar Binacional), a nonprofit in Tijuana launched in 2004 to assist people with HIV, Susi began receiving antiretroviral drugs. Dr. Patricia González worked at AFABI and recommended Susi for the main outreach job at El Cuete.

Susi has not used heroin since 2001, and her HIV levels have been undetectable since 2005. For people who are battling addictions, homelessness, poverty, and depression—the very people who are living with HIV or at high risk of becoming infected—Susi represents hope. She also provides guidance to those who want treatment and need help staying on it. And she plays a central, if somewhat invisible, role for researchers at UCSD, as she is welcomed in sometimes unwelcoming places like El Bordo.

Two-thirds of the people who inject drugs in Tijuana have latent tuberculosis, but many users wear surgical masks for a different reason. They believe the masks scare away police, who are afraid of catching TB themselves.

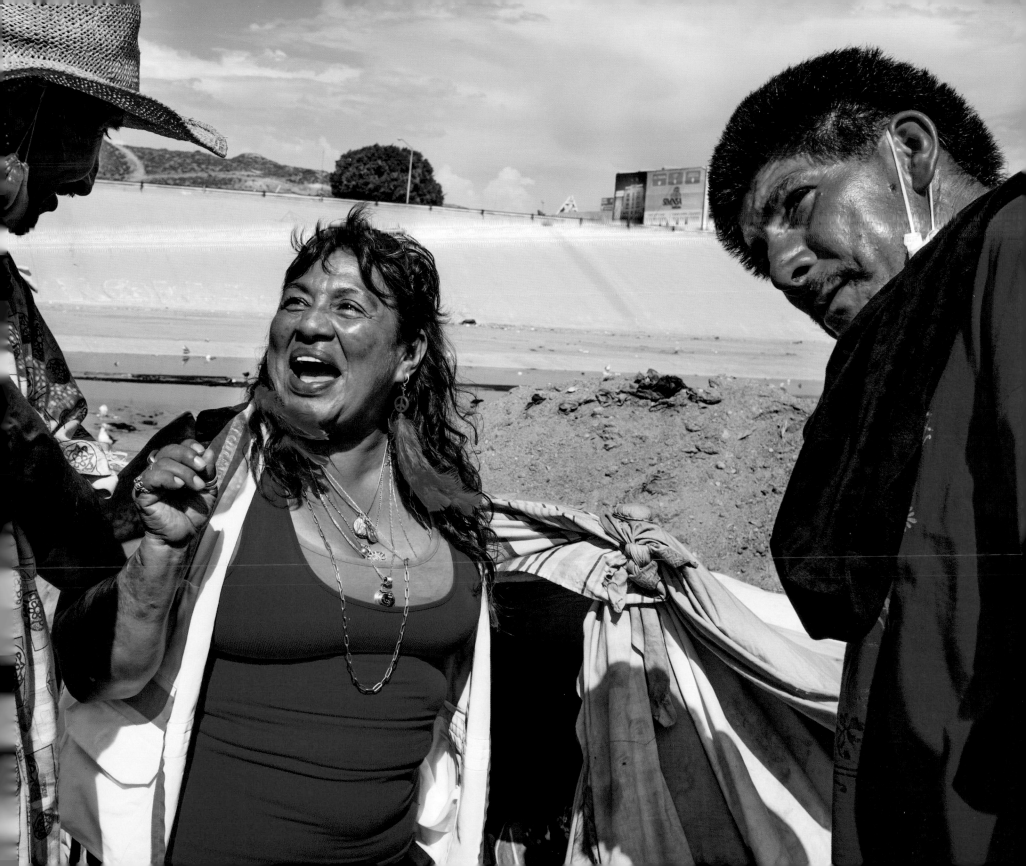

"She looked at me and cried and said,
'What have I turned you into?'"

Susi's son, Chris, sold Chiclets on the street as a young boy and only attended school for a few months when he was seven or eight. "We were under pressure and didn't have many choices," he said. "I didn't have a childhood."

Chris took many drugs before his teens and, unbeknownst to Susi, used heroin from age 15 to age 20. When Chris told her later about his heroin use and other "bad things" he had done, she had trouble believing him. "She looked at me and cried and said, 'What have I turned you into?'"

Chris and his girlfriend had a baby in January 2015. He was 27 and had been off all drugs for one year. "I want to be a different person, a normal person," he said. He had a close—if sometimes combative—relationship with Susi. "Despite everything, she's a good mother. If you always think about the past, you'll never move forward."

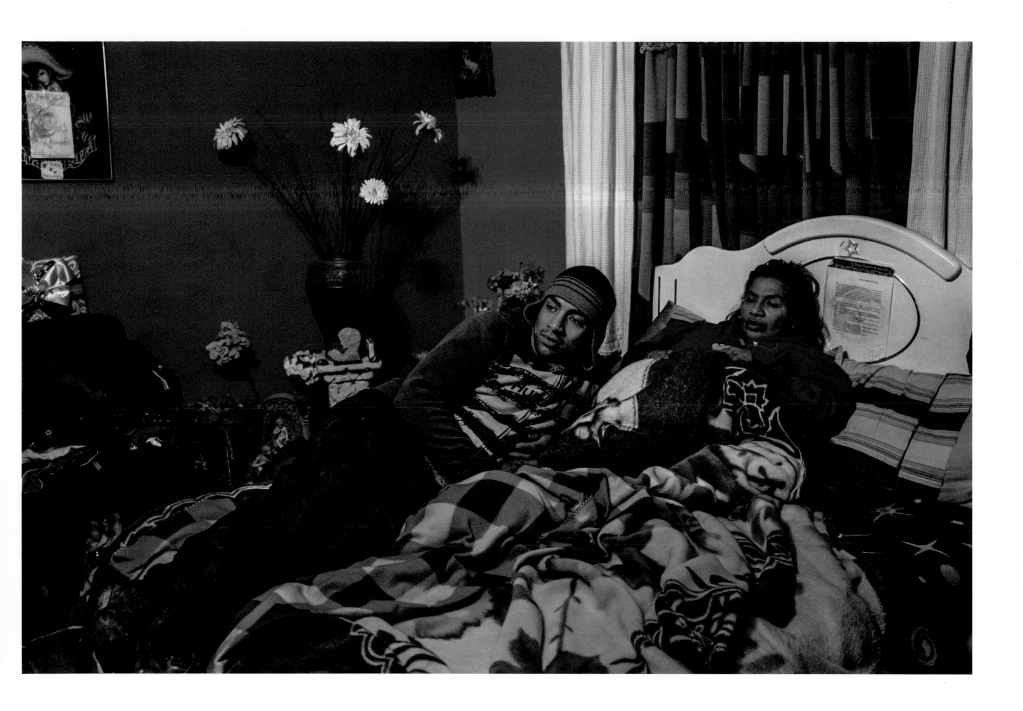

The CAPASITS HIV/AIDS clinic is located on the outskirts of Tijuana and can take more than an hour to reach by bus from downtown. To avoid losing a whole day's work, patients have to arrive at CAPASITS in the early morning, which means Susi leaves her home before dawn.

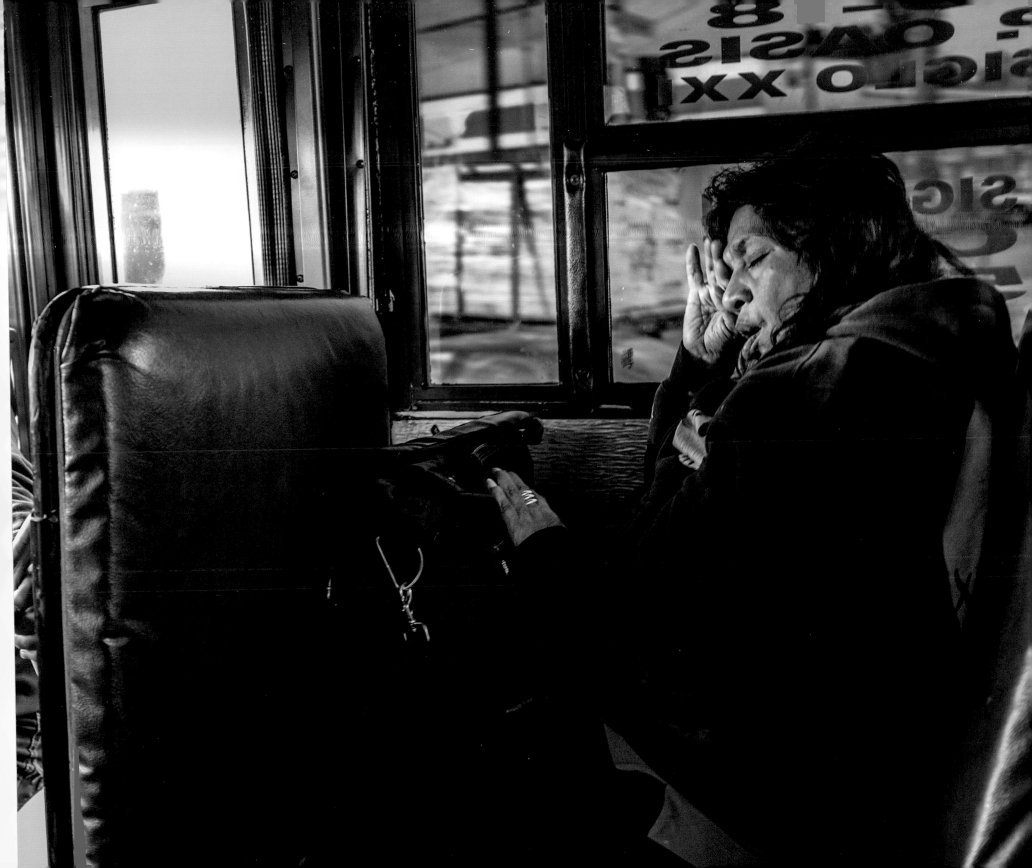

Lesly Zulema Sanchez, a onetime gang member from Los Angeles, went by the street name of China. In the evening, she sometimes left her home in the canal, crossed the four-lane rápida, and walked the few blocks to the red light district.

When China was born in 1985, her family lived in Ensenada, an hour's drive south of Tijuana. She said her father had a heroin addiction and repeatedly beat her mother. "The last time he hit her, he said, 'I made a contract with the devil and I'm going to kill you first, then my kids, then myself.'" Her mother fled to Los Angeles with 11-month-old China and her six-year-old brother.

She was a smart student and made the honor roll at Samuel Gompers Middle School in a rough South LA neighborhood. "I didn't do heroin over there," she said. "I didn't know heroin." She left home after her mother started dealing drugs and became violent. "She hit me with a long metal pole across the back. I turned 12 on the streets."

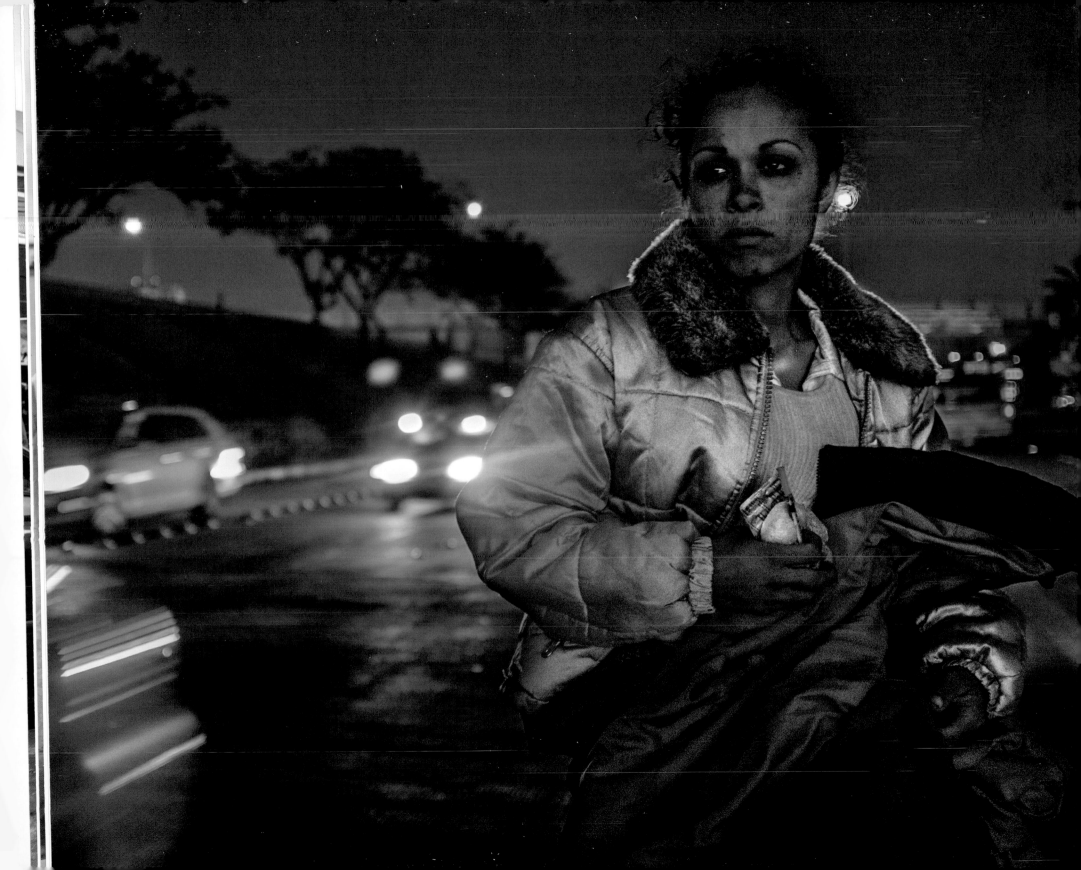

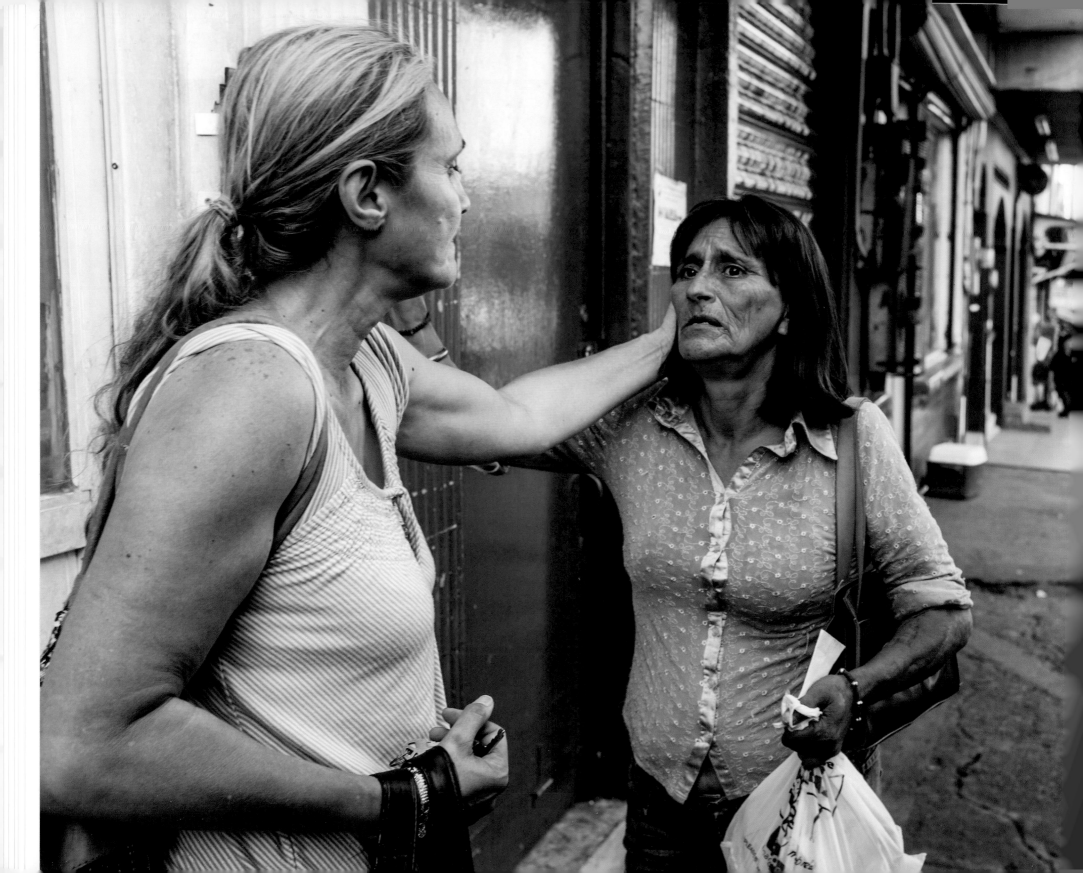

Martha Patricia moved from ailment to ailment, holding her liver one day, coughing badly the next, then vomiting bile. Patricia González often bumped into her coming to and from El Cuete's office. She urged Martha Patricia to take antiretrovirals, but El Cuete was not a clinic and González could only offer medical advice, not the consistent care she needed. "She's my challenge," said González.

Oscar said the life he shared with his two alter egos was "very balanced."

Oscar Villareal, 28, earned his living as a sex worker in the summer of 2014. During the day he was Beto, a gay man who cruised the park. At night he became Alessandra, Alé (pronounced AH-lay) for short, who worked the clubs and the streets in the Zona Norte. "Alé makes more money than Beto," Oscar said, adding that the life he shared with his two alter egos was "very balanced."

Oscar lived in Tijuana as a young child but moved to Wisconsin at eight on a visa with his aunt and a sister. "I went supposedly to go to school but then I ended up working, and I liked the money so I forgot about school." A Greek restaurant hired him as a dishwasher, and his aunt could not convince him to continue with his studies. "I was young and hardheaded. I regret that now." The restaurant owners treated him like one of their own children, he said, eventually promoting him to crew leader.

Oscar married and had a son, entertained as a female impersonator, and bought a new Ford Focus. "Over there, I used to do cocaine, because I was making a lot of money." Then in 2010 he had a car accident. He had no license or insurance, which led to his arrest and the discovery that his visa had expired. After six months at a detention center run by ICE—U.S. Immigration and Customs Enforcement—a judge granted Oscar a "voluntary departure." As ICE explains, "An alien allowed to voluntarily depart concedes removability but does not have a bar to seeking admission at a port-of-entry at any time."

When Oscar returned to Tijuana he started to smoke crystal methamphetamine, a powerful aphrodisiac used by many sex workers.

"Alé gets whatever she wants."

Oscar had his first HIV test in Wisconsin when he was 18. He was nega-tive. When he took another test on Tijuana's Gay Pride Day in 2013, he was still uninfected.

Gay men and transgender women have the highest HIV infection rates of any group in Tijuana. Selling sex further increases risk, as does smoking crystal meth. "Alé gets horny and crazy and wild," said Oscar.

He said Alé scared him. "Alé gets whatever she wants. She is a very spoiled girl. She's a very dangerous girl. She is very, very strong. She is my boss. I listen to her sometimes. And Oscar, he is kind of like Alé but more mellow, not that aggressive."

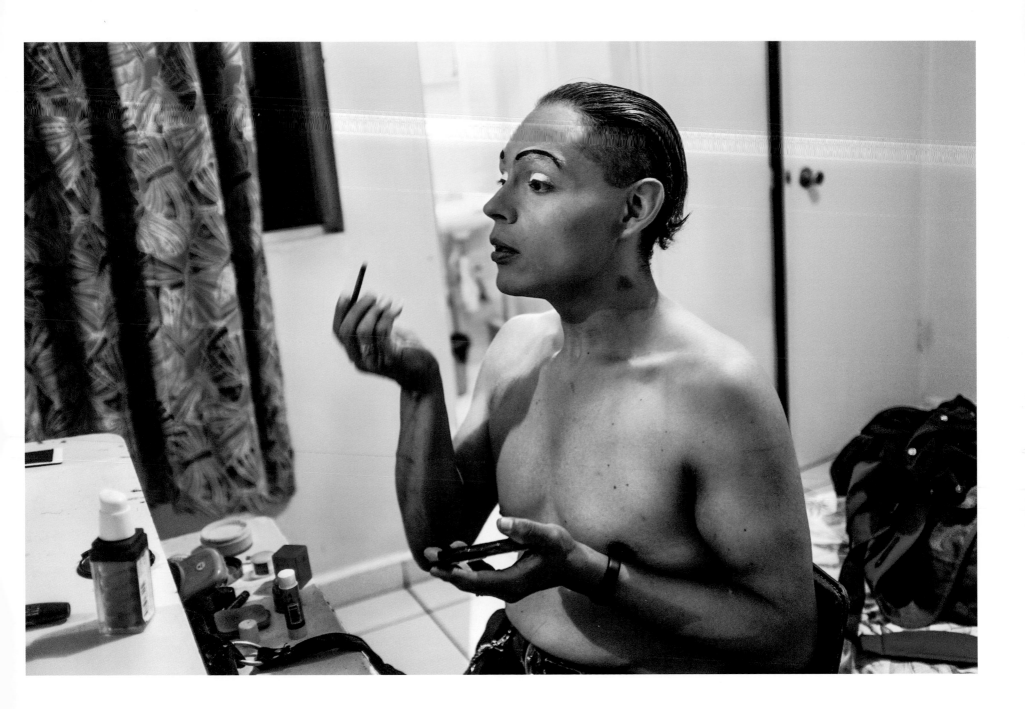

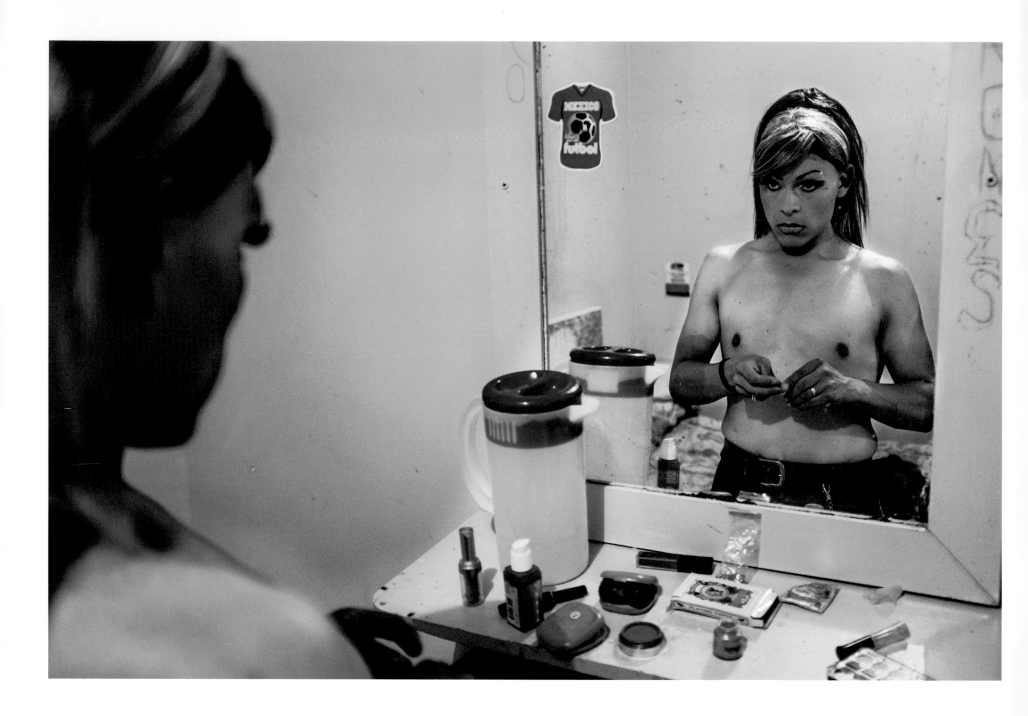

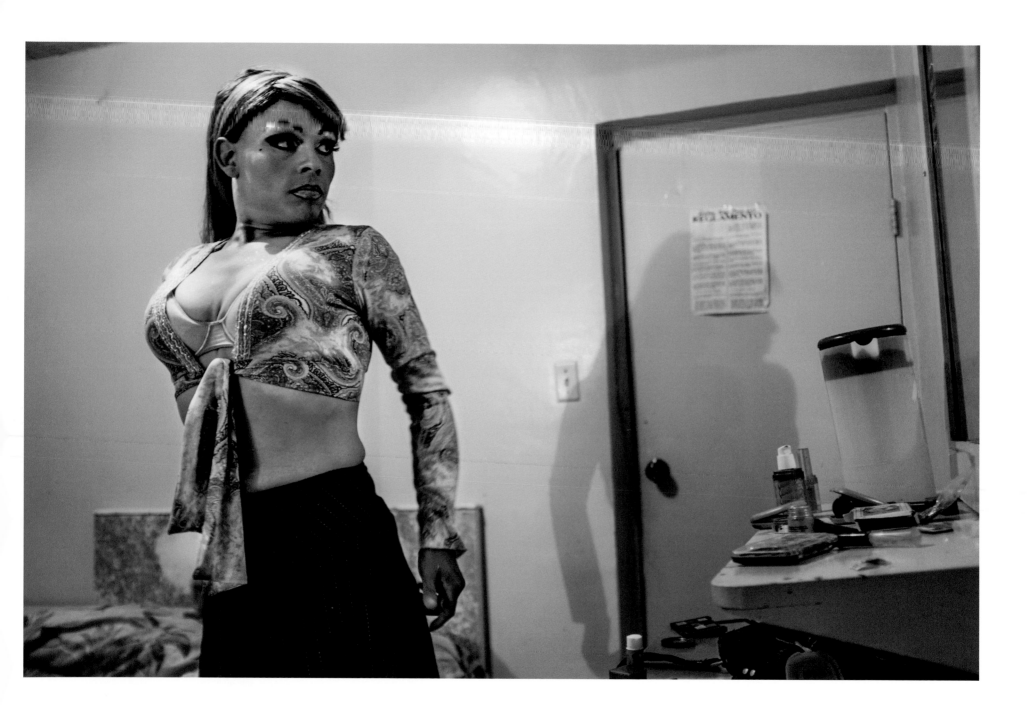

"They'd say, 'Play with my thing and I give you a candy.'"

When Oscar was a boy he regularly returned to Tijuana to see his mother, and he had his first sexual experience there when he was 10. "I was on the streets most of the time playing around, and there were a lot of old guys," he remembered. "They'd say, 'Play with my thing and I'll give you a candy.'" Back in Wisconsin, he continued to trade sex with older men for treats and money. "It was normal to me."

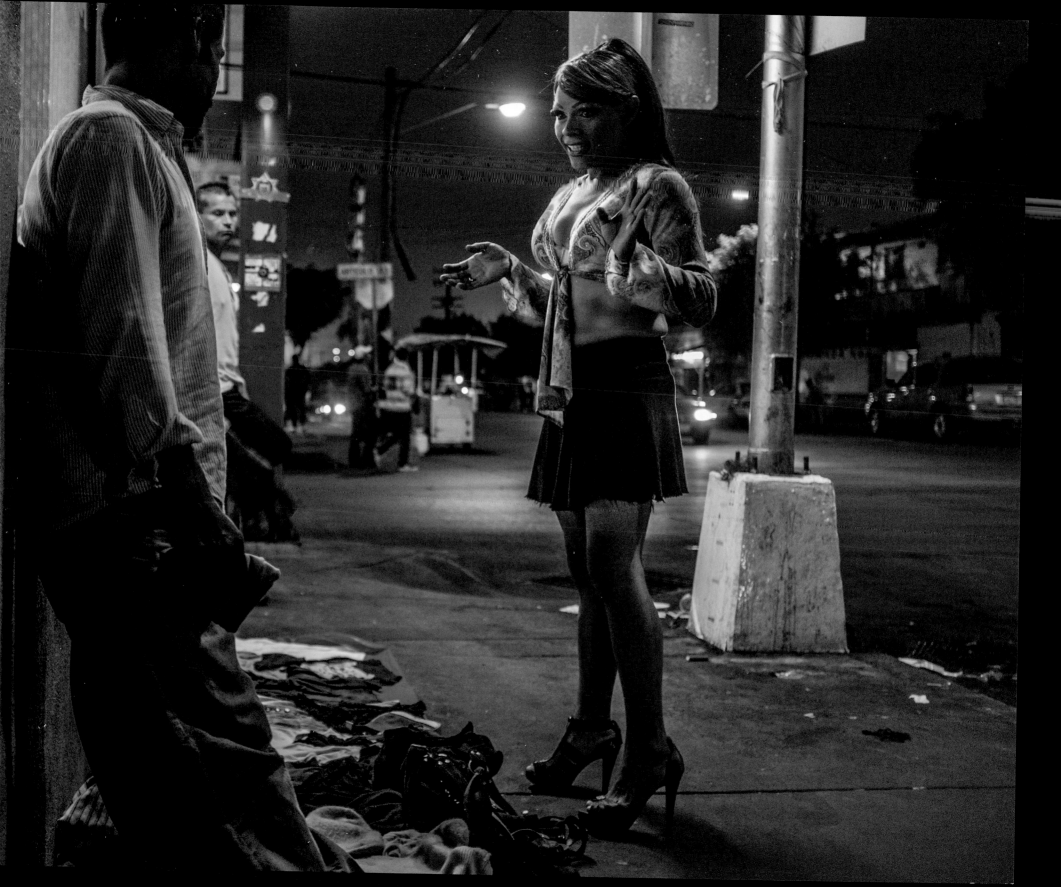

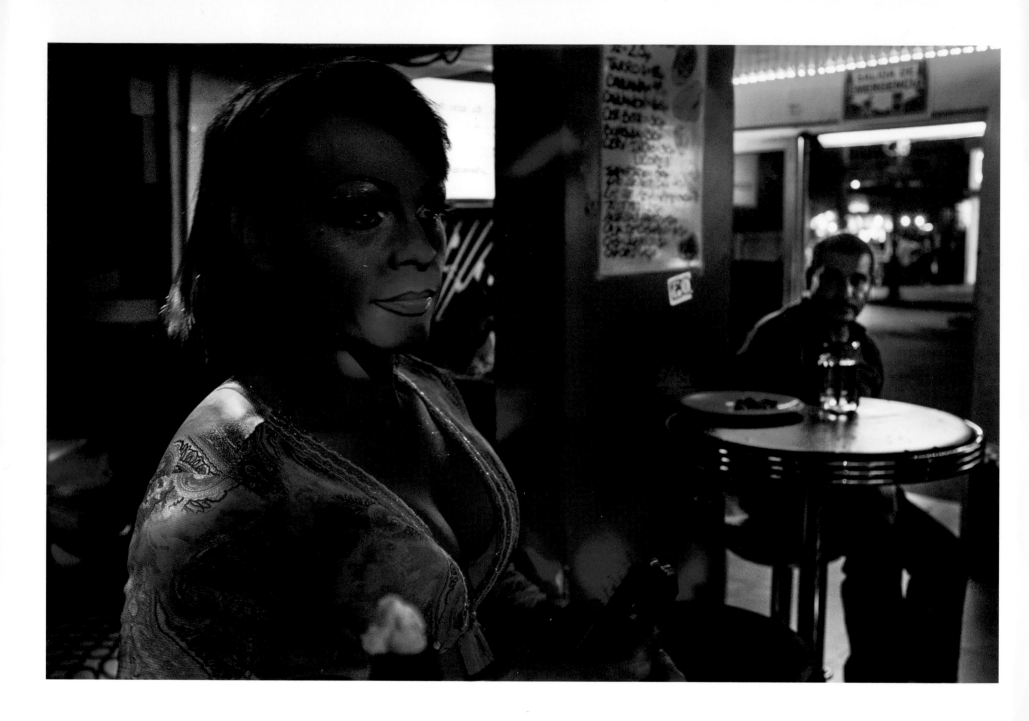

Oscar was appalled that so many deportees ended up living in El Bordo. "I think those people are nuts. Sometimes people ask me for a coin or whatever, and they say, 'Oh, I'm deported.' I'm like, I'm deported, too, and I try to survive in a different way."

Alé mainly had U.S. clients. "They confuse me because they want Alé, but then they want Alé to behave like Oscar. I don't like that. Why? Why do they do that?"

Often, Oscar explained, the clients wanted Alé to be the insertive partner. "That's strange, weird. It bothers me when I'm Alé and they try to touch Beto's things. I don't like that. They're supposed to be locked in a safe."

Male-to-female transgenders often have male clients who like to receive anal sex but do not identify themselves as gay. In their minds, there is no stigma if they are having sex with a woman, even if she has a penis.

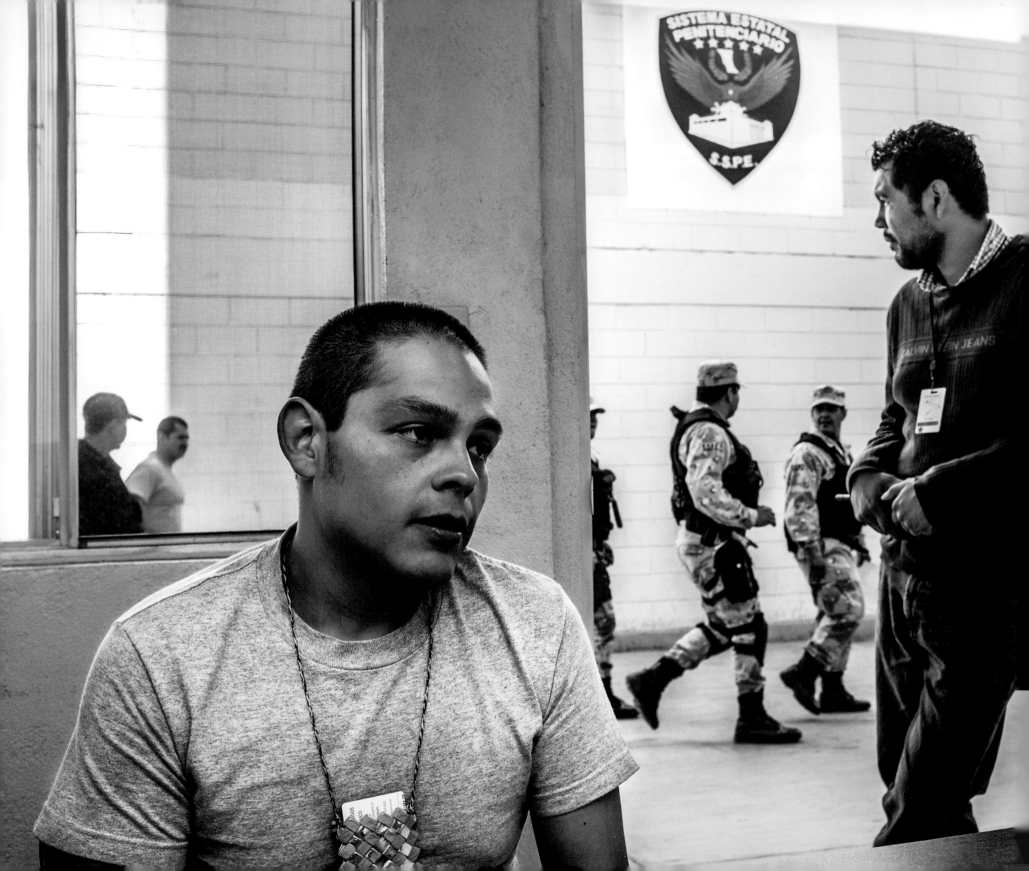

"My lawyer said I'm going to get five years"

In September 2014 the police arrested Oscar, who was coming out of a weeklong meth binge. A search allegedly found that he was carrying half a kilo of crystal and he was locked up at Tijuana's La Mesa prison, which houses 6,000 inmates. "The police put the drug on me," he said. "With no witnesses, my lawyer said I'm going to get five years."

SER is the main HIV prevention program in Tijuana that serves gay men and transgenders. Its staff regularly visits La Mesa prison to conduct rapid tests for the virus and educate inmates about how to protect themselves. SER's Kristian Salas tested Oscar and found that he was positive. The prison moved Oscar to a cell with six other HIV-infected inmates, who received double helpings of food. "Kristian told me I shouldn't be sad," said Oscar. "He told me it was like diabetes, and people don't die as long as they take the medication. I'm not sure about that. Only time will tell me the truth."

In February 2015 Oscar said his CD4 count was 353, and he complained that CAPASITS was not giving him antiretrovirals. Mexico's guidelines at that point called for treating all HIV-infected people, regardless of their CD4 count.

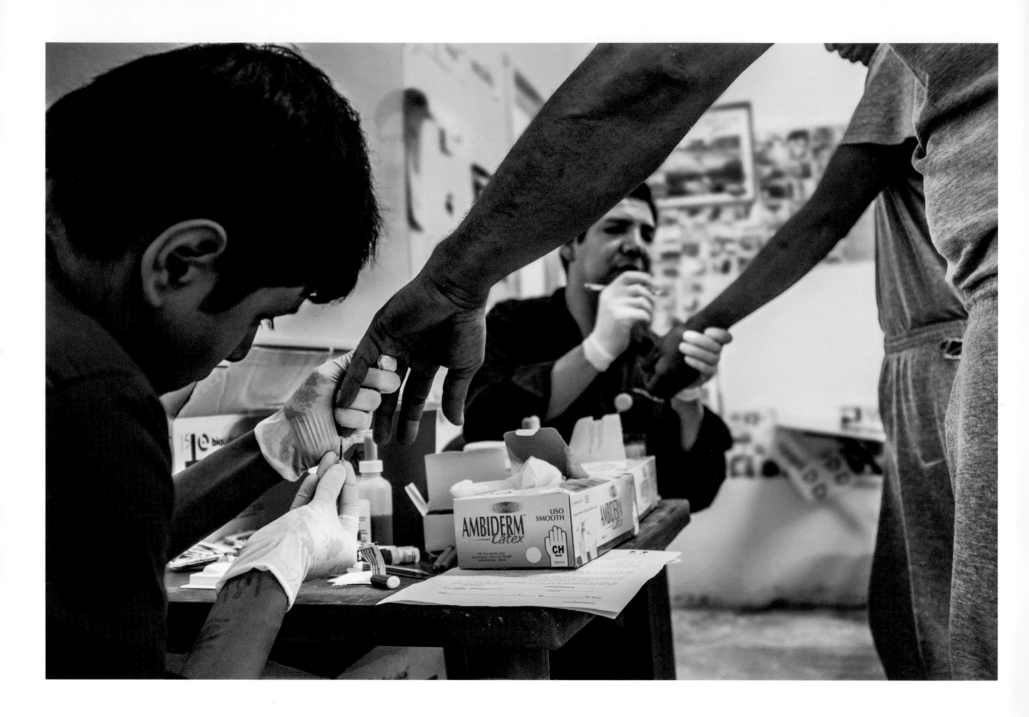

"HIV is not the worst thing that could happen to them."

SER's Erick Martínez (left) and Kristian Salas conducted HIV tests on about 400 inmates at La Mesa prison in 2014. Oscar was one of only four who tested positive. Kristian completed a master's degree at Universidad Autónoma de Baja California studying HIV risk behaviors in male-to-female transgenders.

Erick also did HIV testing at COCUT (Comunidad Cultural de Tijuana), a meeting place that offers services for services for LGBTIs—lesbians, gays, bisexuals, transgenders, and intersexuals (who, biologically, are not strictly male or female). He is HIV-infected himself, and when he tells people they have tested positive—which he has done more than 50 times—he stresses that "HIV is not the worst thing that could happen to them."

When Erick found out he had HIV, he had just started a new job working in the kitchen at a department store. "They told me people in my condition couldn't work in the food area," he said. "At the end of my training period they required that I resign."

On Halloween in 2014 Erick dressed as a witch and distributed gift packets of condoms and lubricant at a COCUT booth he set up on downtown Tijuana's main street, Revolución Avenue.

Erick moved to Tijuana in 2011, in part to escape the discrimination against gays in his home village in Tamaulipas state on the Texas border. "When I got here, I could dress how I liked and behave how I wanted," he said. When he tested positive, he was not surprised. "I had the idea this could happen because of my lifestyle." CAPASITS has provided him with good care: In 2014 his viral load was undetectable, his CD4 normal. "I feel excellent," he said.

Much as Erick enjoyed Tijuana, he noted the lack of a gay neighborhood in the city or a strong advocacy group. "The gay community here is very weak and isolated. They're afraid, they face discrimination, and they worry about what other people will think. And there are many problems because people fight amongst themselves. There are lots of egos."

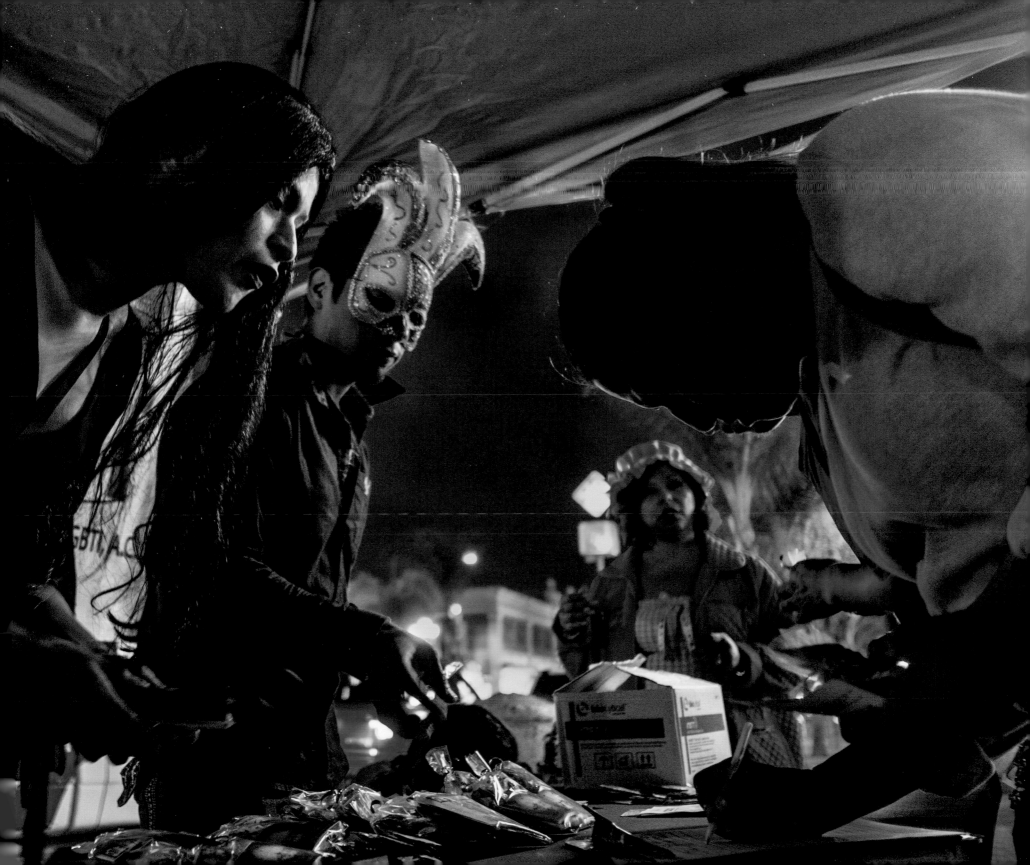

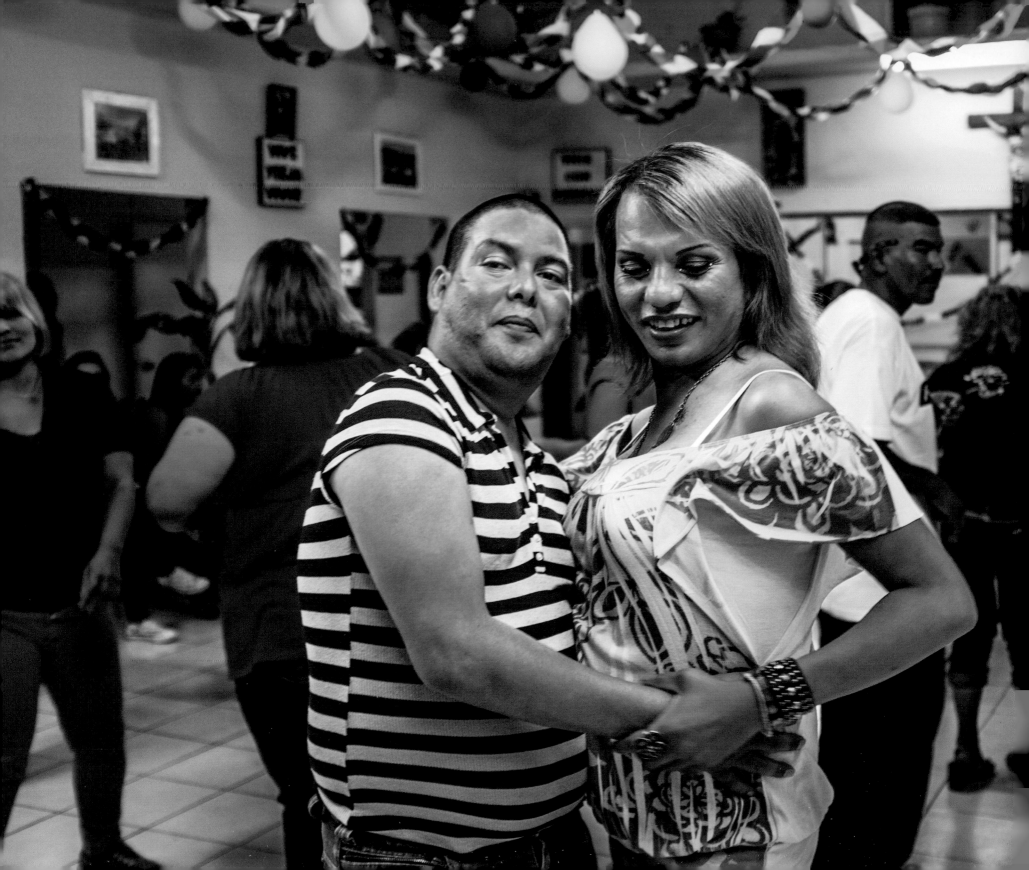

Jessy López (yellow blouse) moved into Las Memorias in 2012, the year she turned 37. "So many people tell me that I'm a miracle from this place because I was, like, dead already," she said.

Originally from Tuxpan, Nayarit, Jessy went to the United States as a nine-year-old boy to live with his sister in San Diego. Jessy moved to Los Angeles at 14 and started injecting female hormones the next year. She got a fake ID at 16 that let her into drag shows, and she made money doing female impersonations as Madonna and Mexican pop stars Paulina Rubio and Thalía. She also did some sex work and Internet porn videos.

Jessy learned she was infected with HIV around 2003 at a clinic in Los Angeles. She was arrested repeatedly for crystal meth, and one bust led to a court-ordered ankle bracelet. "I was crazy, I just wanted to go out and have fun, so I took it off and I put it on my cat," she said. "The cat just went out from the house and I think the thing had started to beep-beep in the office. They came to pick me up again."

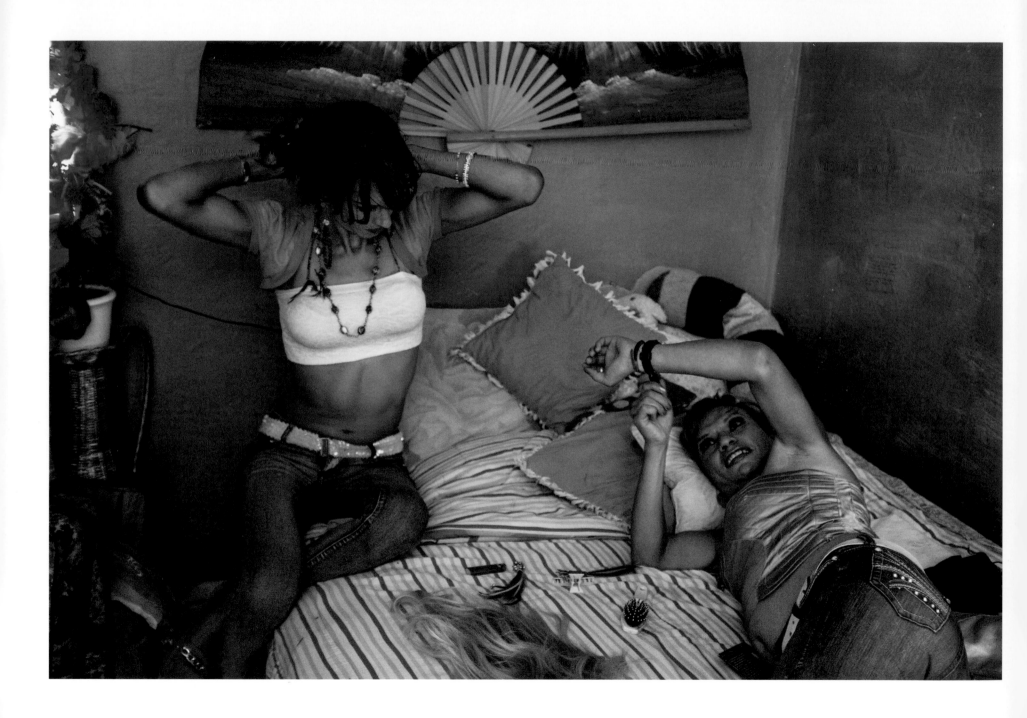

Jessy was deported in 2009 after yet another drug arrest. A lawyer attempted to convince the immigration court to let her stay in the United States, arguing that Jessy's parents had died and she was seriously ill. "I was very skinny, skinny, skinny, skinny because I was like, doing crystal meth and I got TB," she said. But the judge ruled that she could find adequate care and housing in Mexico.

It took Jessy a year to arrange the proper documentation for treatment at CAPASITS. In the winter of 2014 she left Las Memorias, moved into a downtown boardinghouse that serves as a home for many transgender sex workers, and started using crystal again. Her antiretrovirals went by the wayside.

Clients paid Jessy between US$20 and $30 for both oral and anal sex, or they got her high. Sometimes they refused to pay afterwards. "They tell me, 'How can I pay money for sex when I have my wife and you're a man?' And I'm like, okay. Don't pay me. But I will steal."

One afternoon at the boardinghouse with a friend, Jessy admired a watch that she said a client had given her in payment.

"Crystal makes me feel like the hottest girl in town," Jessy said.

She returned to Las Memorias in the late spring of 2014 and went back on antiretrovirals. That September, she was kicked out for allegedly stealing a bottle of hair dye, a charge she denied.

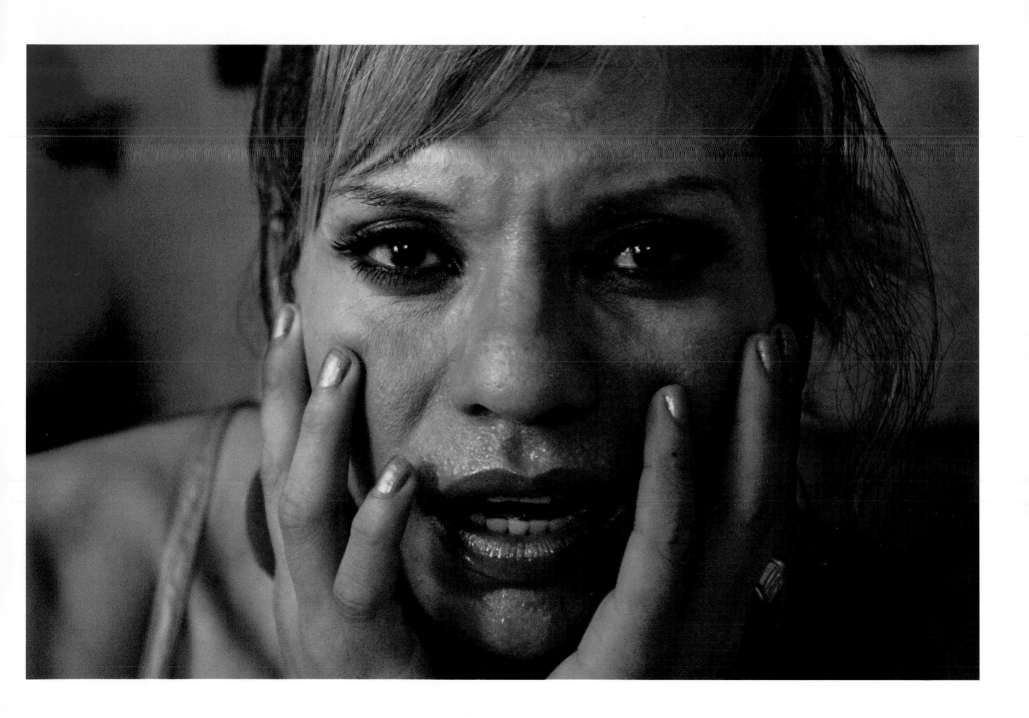

She started injecting olive oil into different parts of her body to look more female.

With signed permission from her father, a butcher in Lázaro Cárdenas, Michoacán, Yovani Sánchez left his home at 14 to perform in drag at a bar an hour's drive away in Zihuatanejo. Renaming herself Fernanda, she got heavily into cocaine and started injecting olive oil into different parts of her body to look more female. "I put in liters of it," she said.

A friend convinced her to buy a 10-milliliter syringe from a veterinary store so she could get the female curves she wanted more quickly. "I had three shots very fast, the third one in the ass, and I started to cough and feel the oil in my throat," Fernanda remembered. "I passed out and woke up in the hospital. The oil had gone to my lungs." For the next year, she had trouble walking.

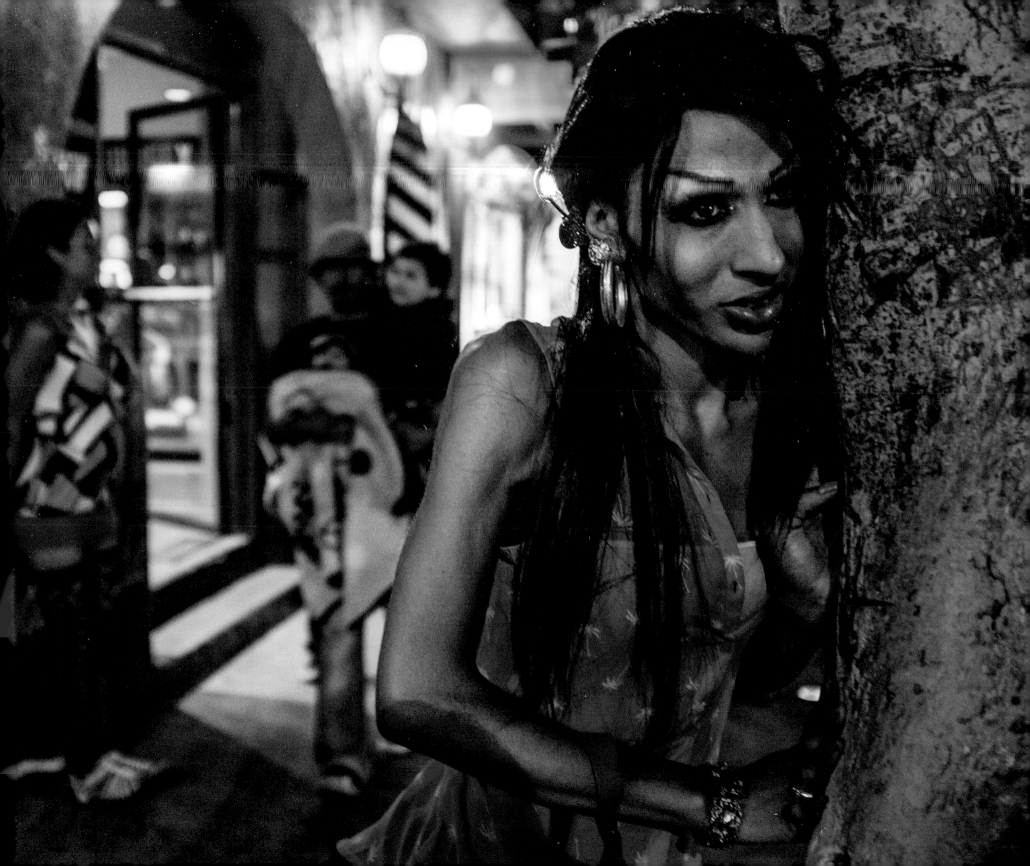

"Sometimes the customers are very bad and make you do it without condoms."

Fernanda loved to decorate her room and moved around the furniture every few weeks. After she got a TV from a client, she endlessly played videos of pop stars like Spain's Mónica Naranjo. Another of her regular pleasures was smoking crystal, which she bought around the corner. A US$3 packet was enough to get high with a friend. She made pipes out of old lightbulbs (*globos*) by removing the electrical part and piercing a hole at the widest diameter to let in air. In the Zona Norte, "Do you want a *globo*?" means "Would you like to smoke some crystal?"

A recent study of more than 2,000 transgender women in Los Angeles found that smoking crystal meth doubled their risk of becoming infected with HIV. Globally, transgender sex workers have an HIV prevalence of 27.3%, according to the most authoritative estimates available. Fernanda understood that she was at high risk of infection and used condoms regularly—but, she acknowledged, not always. "Sometimes the customers are very bad and make you do it without condoms."

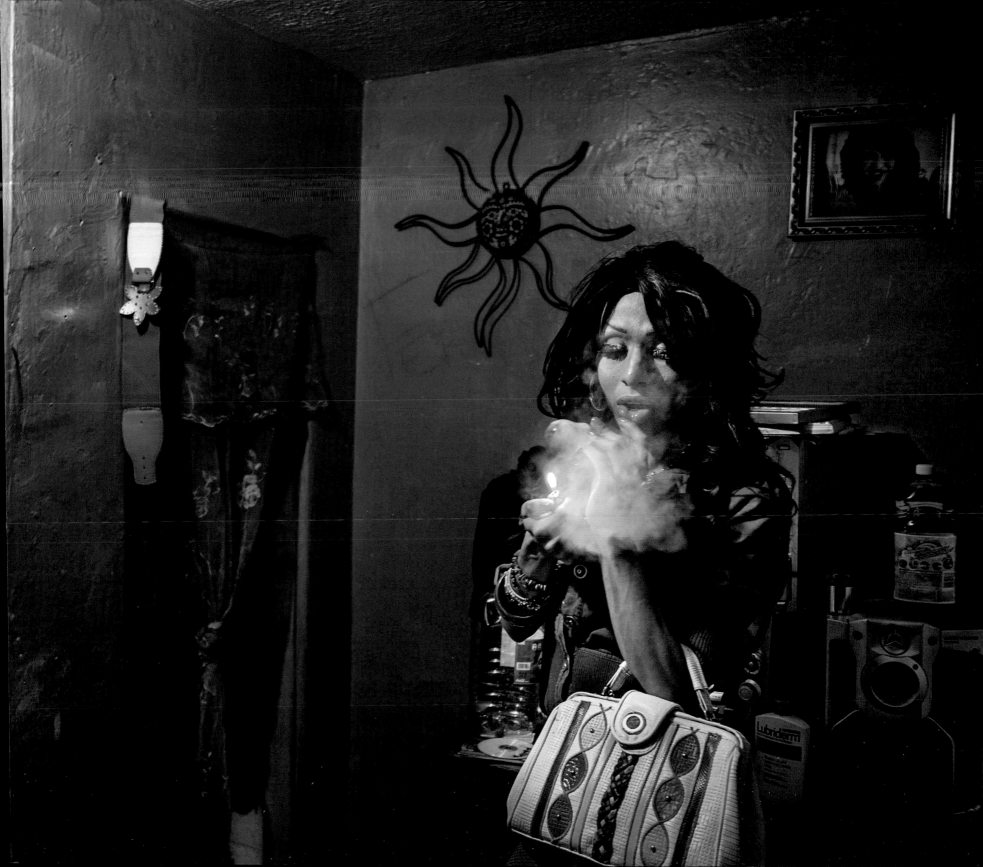

Fernanda was popular with clients and other transgenders but keenly missed being part of a family. "I am alone," she said. "I have no one."

In September 2014 she said she had been tested for HIV about 30 times. She was 26 and had been selling sex for eight years. Her last test, six months earlier, was negative.

Tijuana requires that sex workers carry a card that shows they have registered with the municipal health department and are receiving monthly tests for HIV and other sexually transmitted infections. If they are found to be infected with HIV, the card is revoked. A study by Strathdee and Patterson's group found that of 410 sex workers they interviewed, only 44% were registered. Fernanda said she once had a card but no longer bothered with it. "Nobody asks for it," she said. "And if someone does ask, you just give money. Everything is corrupt here."

In November 2014, Fernanda tested positive for the virus. It was not being infected that got her down, she said, but the prospect of *la burla*—the mockery. One afternoon she decided to go to Prevencasa to ask for treatment, but a client stopped her on the corner. They talked for a moment then headed back toward a motel named *El Deseo*, The Desire.

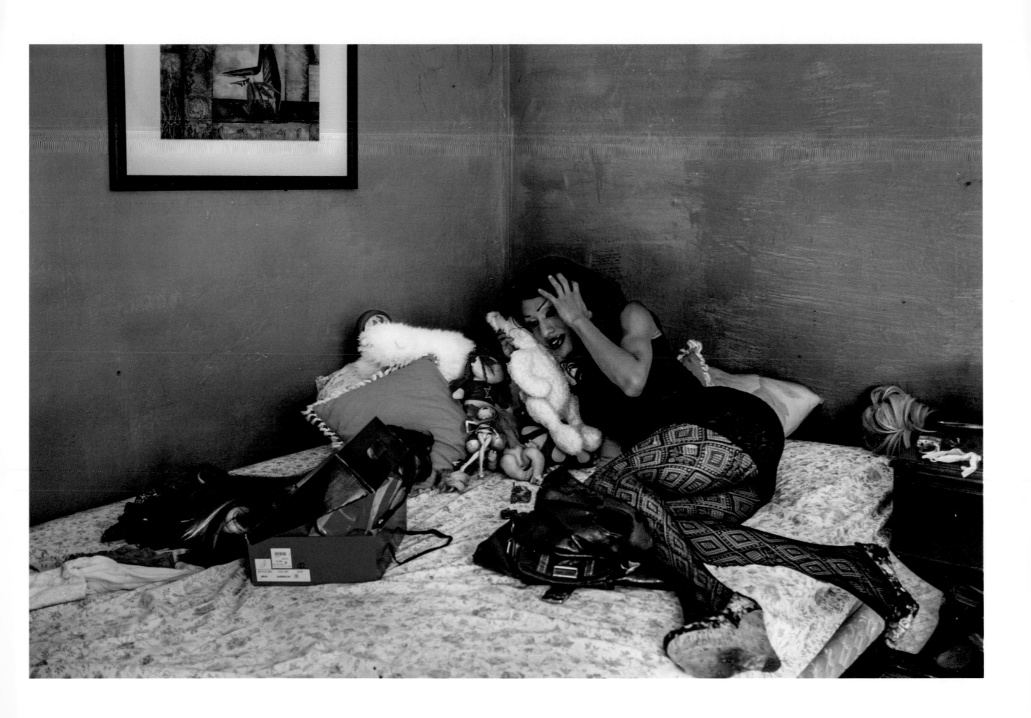

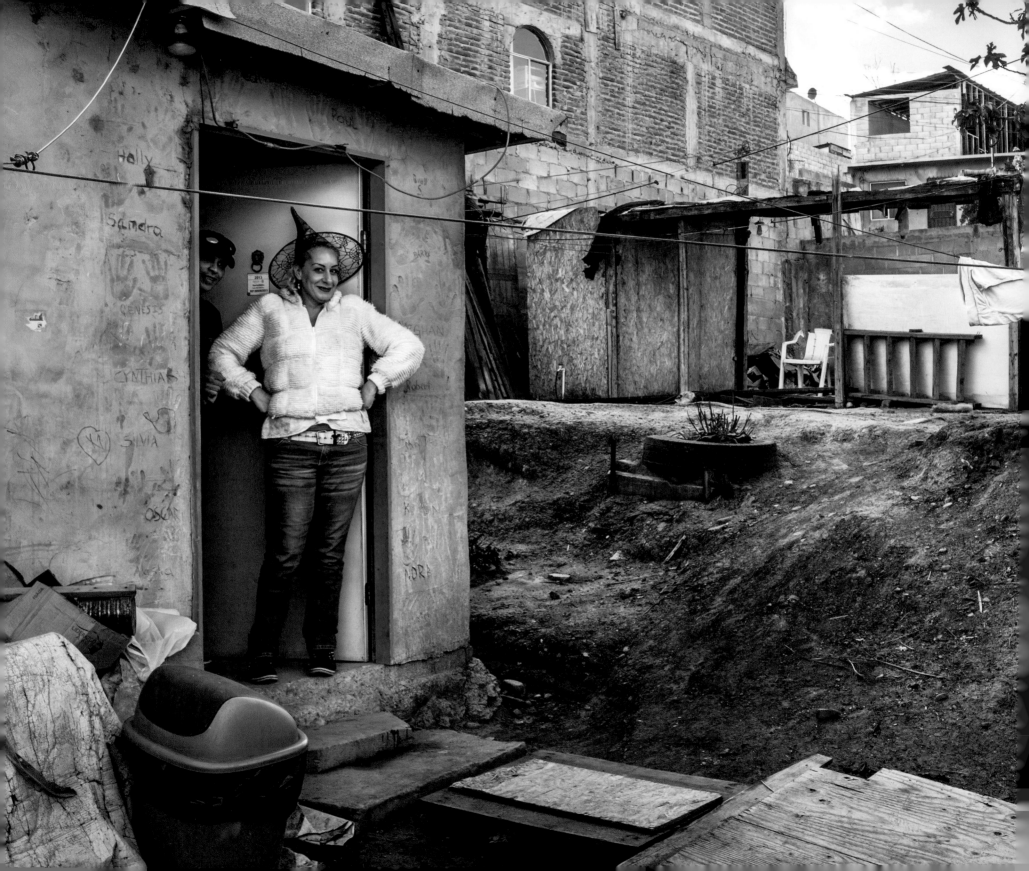

"He told me, 'I'm sorry, I can't lie to you more.
I'm gay. I can't be with you anymore.'"

On Halloween 2013 Nelly Karina Flores, 34, was living at her mother's house when Maciel Larrañaga, who had been the first of her six husbands, stopped by for a visit.

Nelly and Maciel fell in love in high school, she became pregnant, they married, and six months later he came out to her. "He told me, 'I'm sorry, I can't lie to you anymore. I'm gay. I can't be with you anymore.' Those are the words he said. I wanted to die because I was so depressed."

Nelly and Maciel lived together for another 10 years, "like a sister and a sister," she said. Then he moved in with his mother, who helped raise their daughter.

They remained close friends through each of her subsequent marriages. She had a son with husband number two, but said he was lazy and too macho. Number three, father of a second son, was a bank robber who was shot and killed during a heist. Four had a serious meth problem and moved to another Mexican state at his mother's insistence. Five got the boot because she caught him cheating, and six was beaten to death by a baseball bat in a drug deal gone sour.

She assumed she caught the virus from him when they shared a tattoo needle.

In 2010, Nelly was working reception at a hotel that fronted for a brothel. She decided to take an HIV test with all the girls and, to her astonishment, tested positive. Maciel had made comments that led her to suspect he was infected, but they had stopped having sex more than a decade earlier. She later assumed she caught the virus from him when they shared a tattoo needle.

The news exacerbated Nelly's long-standing problem with crystal meth. "When I saw the test results, I wanted to die. It was so devastating. I was depressed, and I got more down in drugs. I got down and down and down and down in drugs. I didn't come home for like four months."

Nelly had been to CAPASITS in the past, but she did not know her CD4 count, had never been prescribed antiretrovirals, and had not seen a doctor for her infection in 10 months. Still, she was doing well. Maciel had difficulty staying on treatment and had been struggling with advanced AIDS-related pneumonia. "He stopped breathing two times, and I did CPR and he came back to life again," she said.

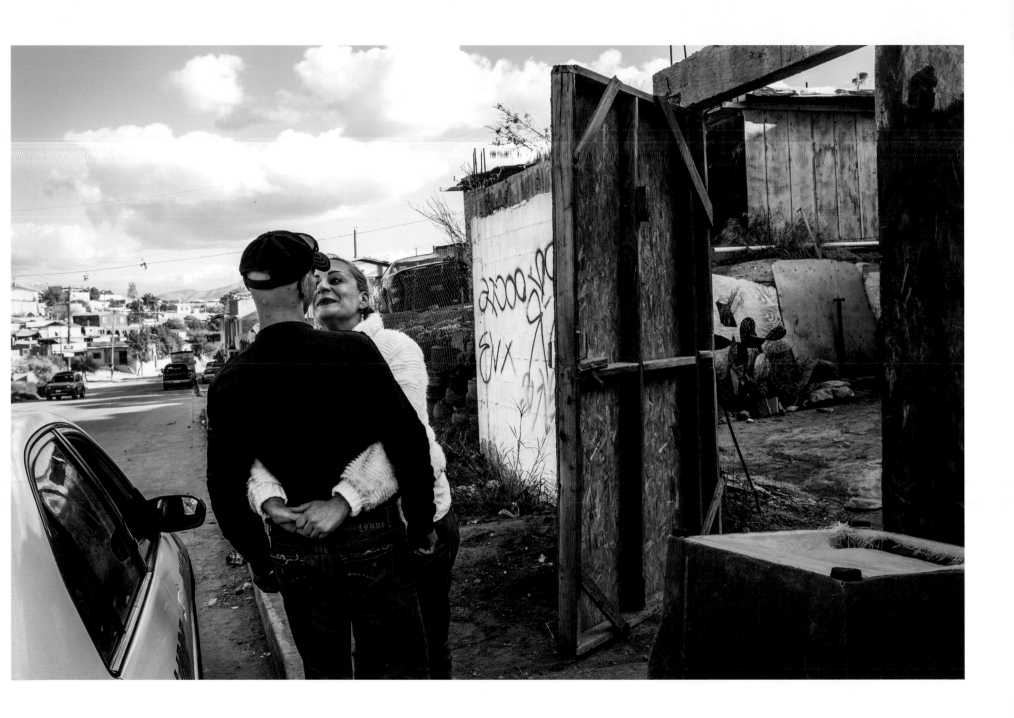

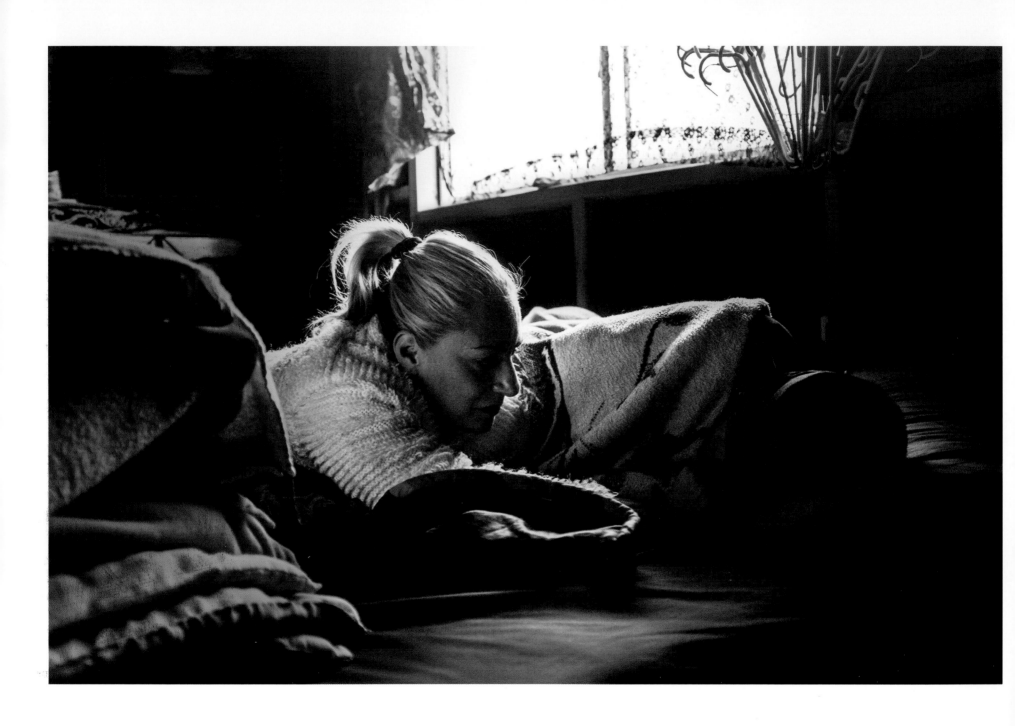

Nelly's two boys lived with her at her mother's house. By the end of 2013, she had stayed off crystal meth for nearly a year. "I feel better than ever," she said.

Despite her modest means, Nelly started to care for Brenda Castrejón, a 43-year-old woman from San Diego with late-stage AIDS who had been deported for selling and transporting crack cocaine. Brenda lived with her 11-year-old son in a gated community of trim townhouses. But the inside of Brenda's house was as broken as her immune system. There was a hole in a bathroom floor where a toilet used to be. Doors had missing chunks. A book lay on the couch, *Tan Lejos de Dios* (So Far from God); the second half of the popular Spanish phrase is "and so close to the United States."

Brenda said she never used crack herself. "I'm too vain to be a drug addict," she said. "When you use drugs, your skin shrivels up and your hair looks like crap. That was my biggest fear." She tested positive for HIV seven years earlier as part of a routine screening for a job at Televista, a major call center for American companies. "When the doctor told me, I felt something go down me from hot to cold. For the next four months I was cold."

Brenda had a girlfriend then, a Tijuana policewoman, who finally convinced her to seek care. Her CD4 count was 145 in May 2010. She started on antiretrovirals, but only took them occasionally. "You got to eat to take your medication, and sometimes I don't have enough food to eat."

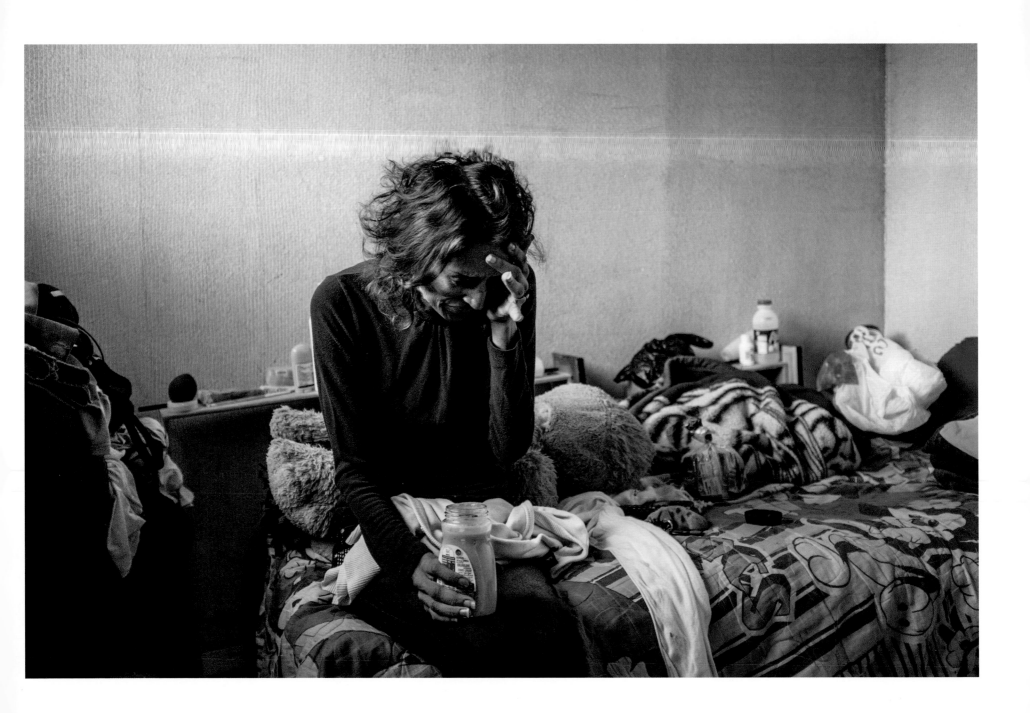

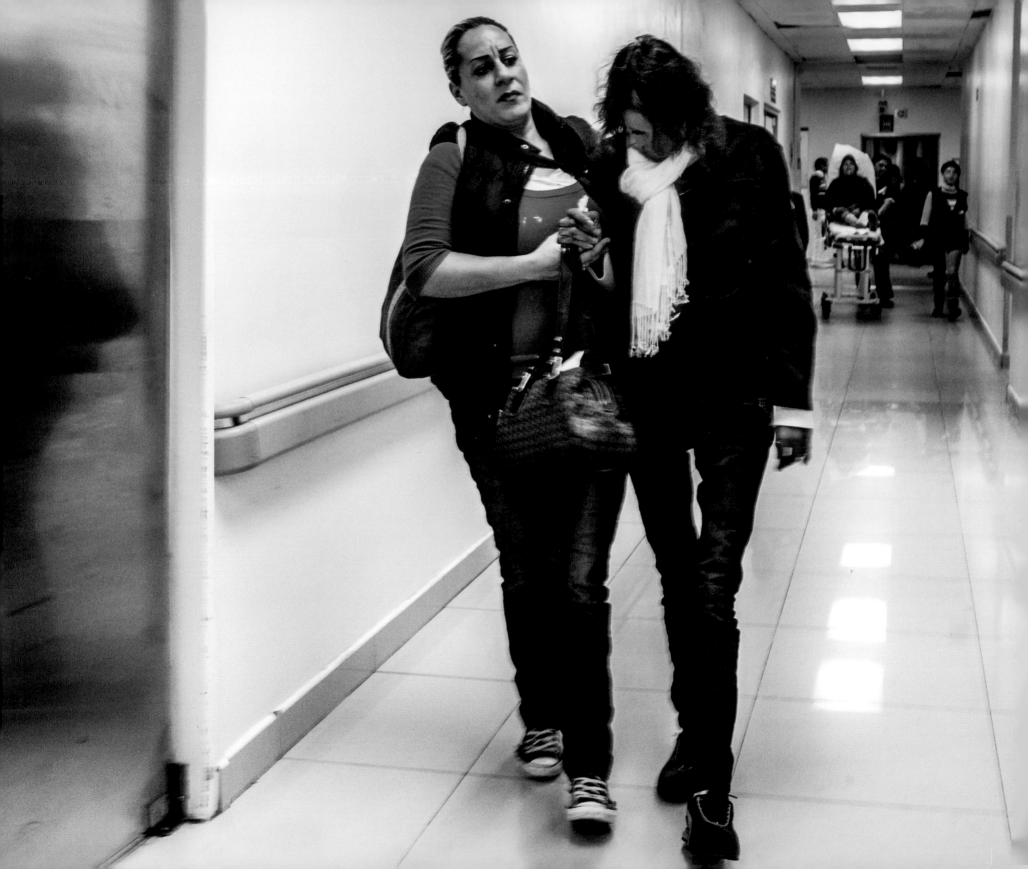

Brenda's girlfriend broke off the relationship, tired of her attitude more than her health problems. "She thought I was letting myself die and withering away, and she couldn't do anything." In early November 2013 she weighed 83 pounds, nearly 100 less than before she got ill.

Her doctor at CAPASITS warned Brenda that she was heading for death. "She lectured me and said, Don't I love my son, he needs me, don't stop taking my medication. I know she means well, and I appreciate it, but sometimes, I don't think people understand that when you're by yourself, it's really hard not to get a little depressed. Meeting Nelly is a blessing because I'm snapping out of it slowly but surely. Right now, you could say I consider myself lucky."

Incessant vaginal bleeding later that November led Brenda to Tijuana General. After she had waited for hours they sent her home, saying she should make an appointment.

Brenda badly wanted to return to the United States. "I know I can get better treatment there," she said. But she worried that if she got caught, she would go to prison for illegal entry.

Brenda died of AIDS at Tijuana General on March 5, 2014.

In February 2014 Nelly started using crystal again, which led to endless fights with her mother. She became too depressed to help others and did not know that Brenda had died until months later. She checked herself into Las Memorias, which gave her a bed in a ward that had a rainbow flag in the doorway and housed the LGBTI residents. "At Las Memorias, they didn't ask me questions, but they listened," she said. "I found friends who had the same problems with drugs, HIV and depression. The people there are lovely."

She began to take antiretrovirals in May 2014. She had a relatively high CD4 count, 586, but said, "I was scared of feeling sick." Maciel's crystal addiction and declining health frightened her, too. "He's more interested in taking drugs than his pills."

That fall she found a new lover, Pedro Farías, who also went by the name Pamela Melissa. Pedro was a married man with children, and Pamela was a drag queen. "She has shot hormones in her breasts, and when she comes here, everyone thinks she's a lesbian," said Nelly.

Maciel died on November 4, 2014. Nelly posted a note on his Facebook page: "Love you forever, my beautiful child."

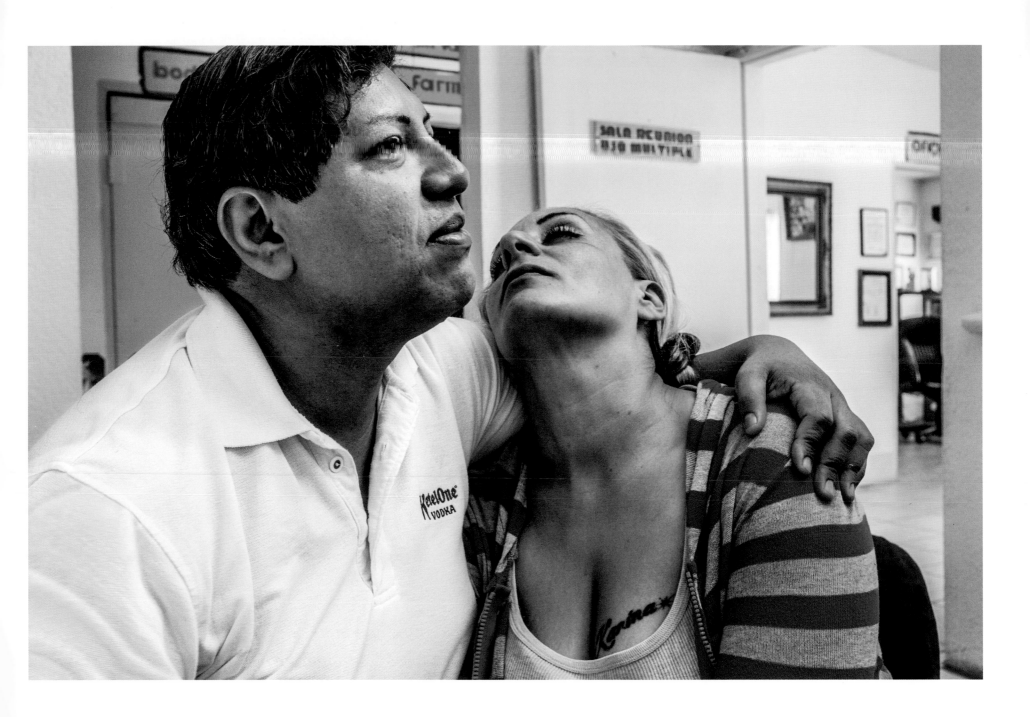

Neighbors complained about living next to a house filled with dying AIDS patients.

At the 15th anniversary party for Las Memorias, the archbishop of Tijuana, Rafael Romo Muñoz, celebrated the Eucharist. Print and broadcast journalists showed up to report on the event.

Las Memorias actually began in the 1980s near downtown Tijuana, but neighbors complained about living next to a house filled with dying AIDS patients who had troubled pasts. With support from CIRAD (Centro de Integración y Recuperación para Enfermos de Alcoholismo y Drogadicción)—a nonprofit that runs several rehab centers—the hospice relocated to the edge of the city at the end of a dirt road. The director of Las Memorias, Antonio Granillo (blue shirt, glasses and mustache), was a recovering addict himself who had received treatment at CIRAD.

The annual attendance of the archbishop at Las Memorias' anniversary celebration conveyed a clear message: The Catholic Church may denounce homosexuality, prostitution, condoms, and drug use, but it embraces HIV-infected people.

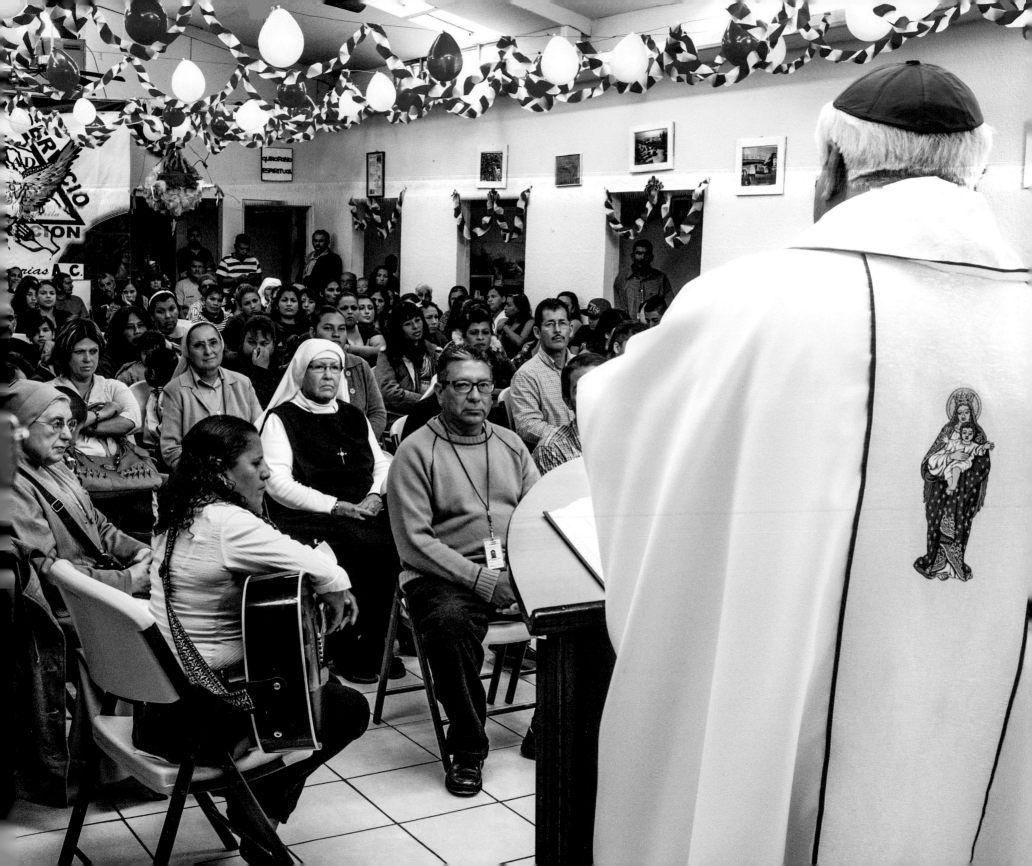

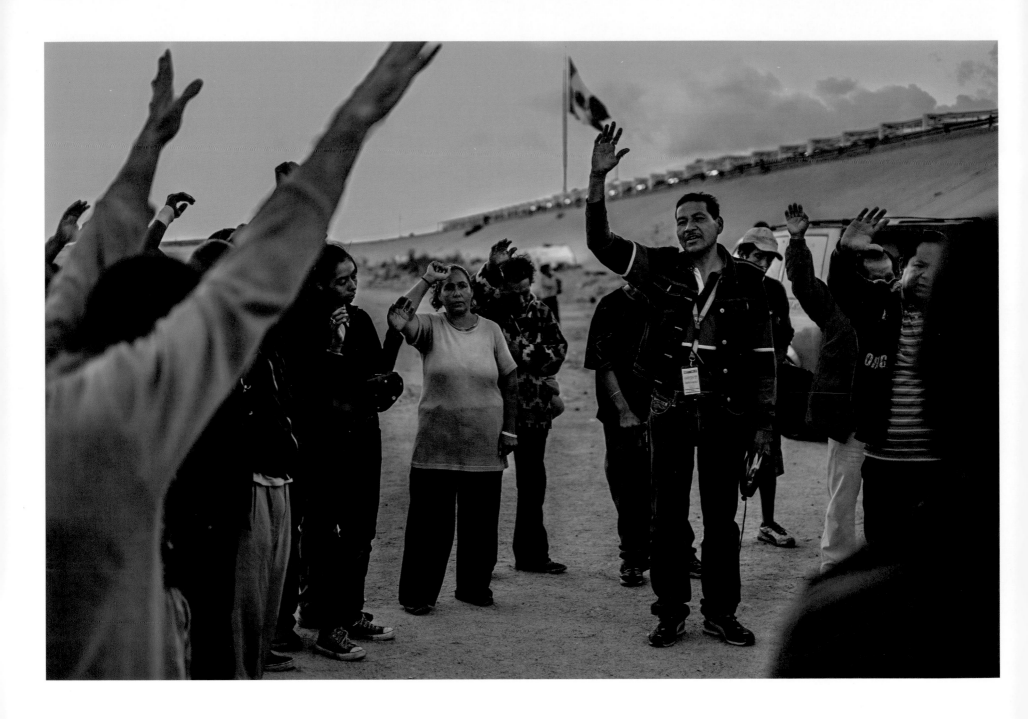

"Most of the centers where the exploitation of addicts happens do not meet the standards and come from the Christian order."

Various denominations visit El Bordo and hold prayer sessions. Some are linked to rehabilitation centers and come to rescue lost souls.

In 2009, the director of CIRAD, José Luis Avalos López, blasted many of the religious rehab facilities. Avalos López, who at the time headed the Interdisciplinary Commission of Rehabilitation Centers, said only 32 of the 80 programs surveyed met government standards. He told the newspaper *El Sol de Tijuana* that many of the centers sent residents to the streets to panhandle or sell goods. "I have nothing against God, but most of the centers where the exploitation of addicts happens do not meet the standards and come from the Christian order," he said.

Inspired by a preacher, Verónica Conrado (purple sneakers), checked into a Christian rehab center for women in late 2013. She was 19 years old.

Originally from Mexico City, Verónica attended middle school in Atlanta, Georgia, for three years. She said that her mother's partner abused her, but "the police weren't sure if I was telling the truth." She asked her mother to send her back to Mexico City.

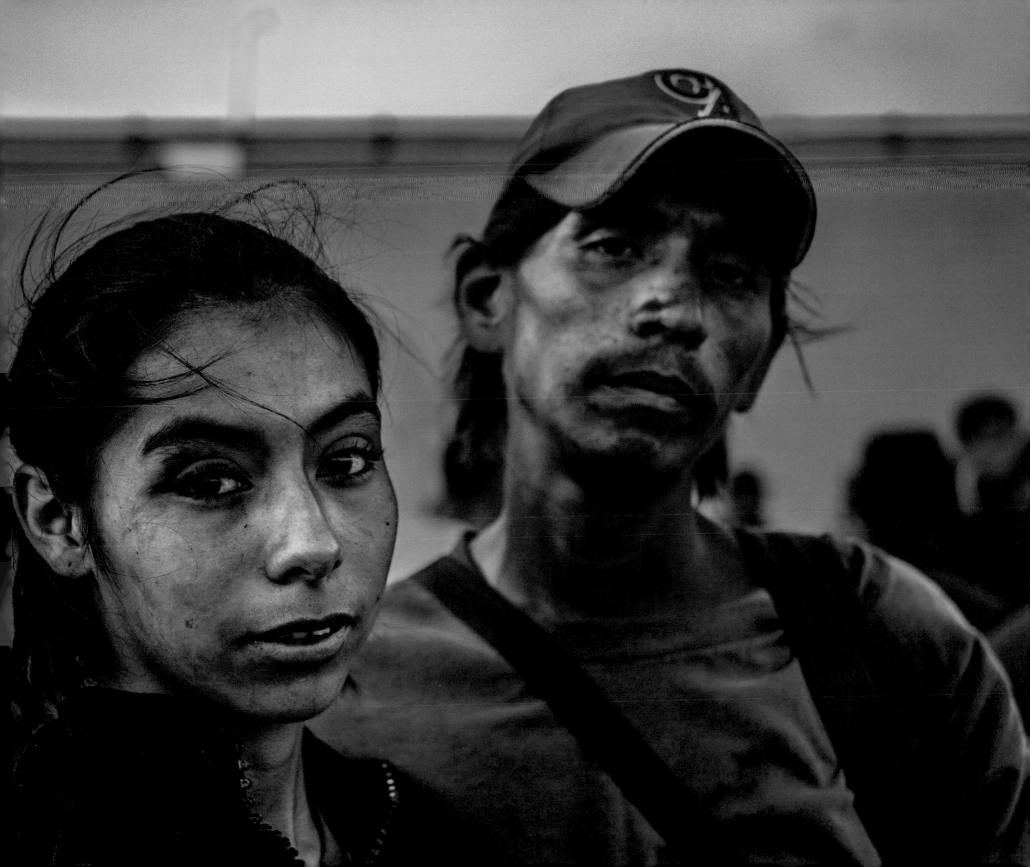

Verónica had a baby girl when she was 16 and came to Tijuana with a boyfriend because he had family in San Diego. "He said they were going to help us," she said. The help never came, she started using heroin, and then they split up. She made money by washing the cars of people waiting in line to cross the border.

She found a new boyfriend, but the state took her daughter away. "They told me she was adopted already," she said. Money was always scarce. Home was a blue tent in El Bordo that she bought for US$4. Food often came from handouts. "I'm sharing needles about once a week," she said shortly before entering the women's rehab program. Her boyfriend checked into the men's equivalent, but Verónica said he left within days.

To her surprise Verónica got through withdrawal with little discomfort, but she was irked when the program started sending her out to panhandle. Continual verbal abuse by the staff added to her unhappiness, and after two months she left.

Verónica immediately returned to El Bordo and began injecting heroin again.

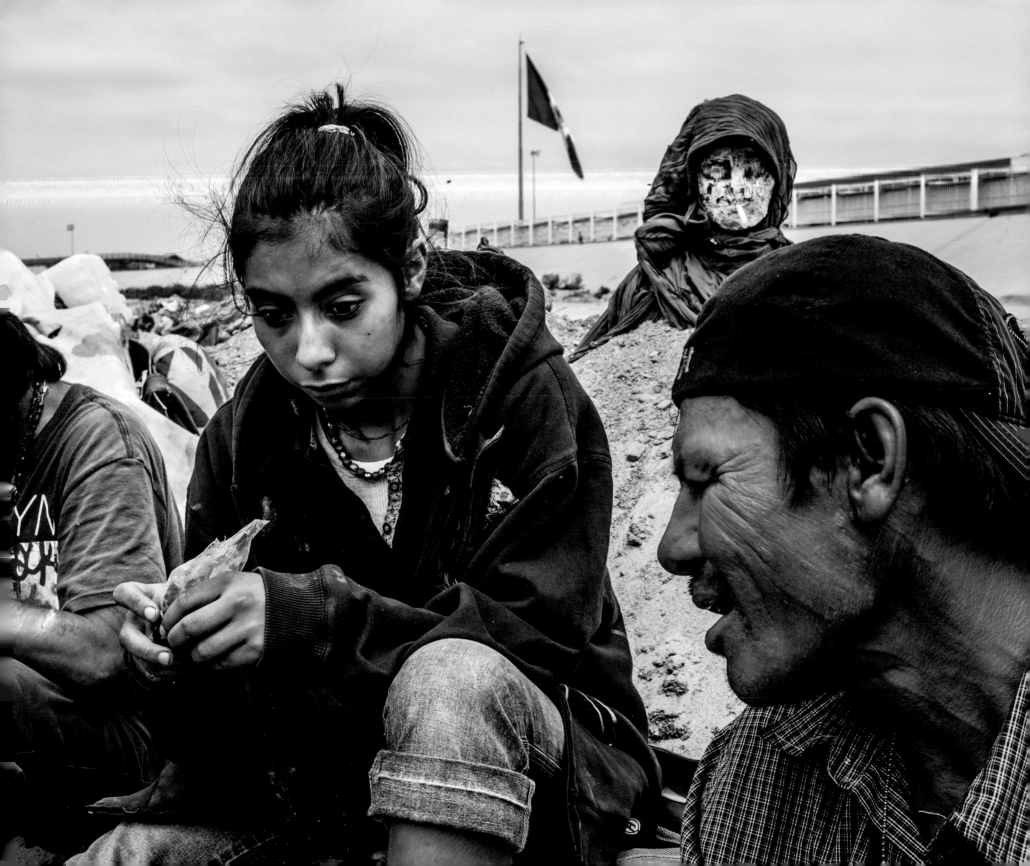

"I was looking for things in the wrong places"

Venessa McNeil grew up in San Diego, and began selling sex at 14 for a man who two years later would father the first of her two boys. "I was looking for things in the wrong places," she said. A crystal meth habit and violent fights repeatedly put her behind bars. She moved to Tijuana in May 2012 with her American boyfriend, an addict who wanted access to cheaper heroin. Both were American citizens, and Venessa had no ties to Mexico. She had never tried heroin before arriving but soon became addicted.

They lived in various motels in the red light district, and Venessa made money working the streets. She said she never shared needles but recognized that she was at risk because he did. "I said, 'You don't know what the fuck you're giving yourself.'" As a participant with El Cuete she had HIV tests every six months, and they were always negative.

Venessa's boyfriend was arrested repeatedly by Tijuana police and finally volunteered to enter a rehab program instead of doing time. She lost touch with him. Severe abscesses on her torso sent her back to a San Diego hospital, where she received methadone and learned she was positive for hepatitis C. When she was released she returned to Tijuana and her habit. For nearly three weeks, she slept in El Bordo. "I didn't have money and I was out of commission because of my abscesses. It was crazy."

*"... working, getting high, working, getting high,
losing my stuff, working, getting high."*

Venessa, at 31 years old, had intact veins in her limbs, but said she liked to "slam" into her neck so she could inject heroin directly into an artery. "I get a straight fucking nod high."

A new boyfriend, who was a recovering addict himself, insisted that Venessa stop using. She entered a residential abstinence program that had locked doors and forced her to quit without an opiate substitute. She hated it. Her boyfriend said she could live at his house, and in February 2015 he paid for her to start methadone at a private clinic. She did not much like that one either. "If he wants me to be clean, I don't want to be a bitch about it," she said. "And I'd rather be living with him than in the streets and working, getting high, working, getting high, losing my stuff, working, getting high."

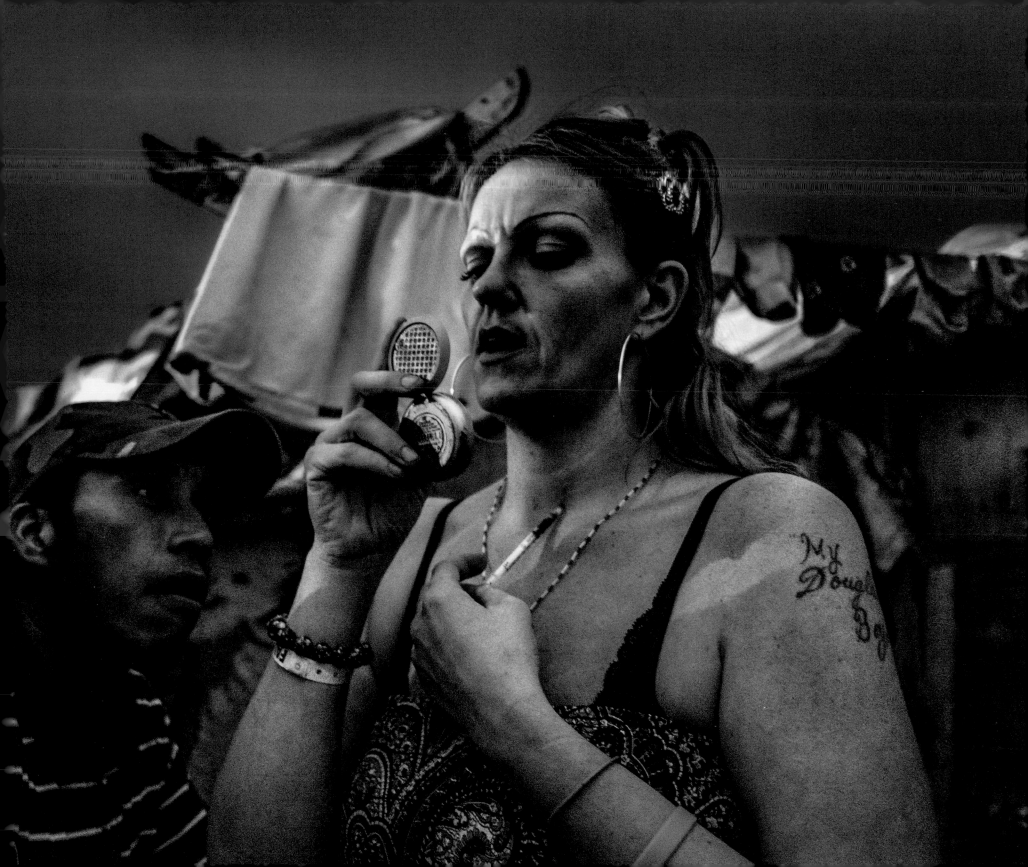

*"There's a lack of information about
what methadone treatment is. The focus
is on abstinence."*

Four miles from El Bordo, CIJ (Centro de Integración Juvenil), a nonprofit center set up originally to address youth drug use, provided methadone in January 2014 for US$3 a day and also had a live-in facility for US$250 a month. "If we really want to have an effective program to confront drug use, the health ministry would need to make methadone free and we'd need money for outreach," said Raúl Rafael Palacios, the director. "There's a lack of information about what methadone treatment is. The focus is on abstinence."

Ericka Rojas, a 32-year-old participant in El Cuete, started using methadone in 2012. She had been in rehab centers four times and always relapsed. "Thank God I'm not infected with HIV," she said.

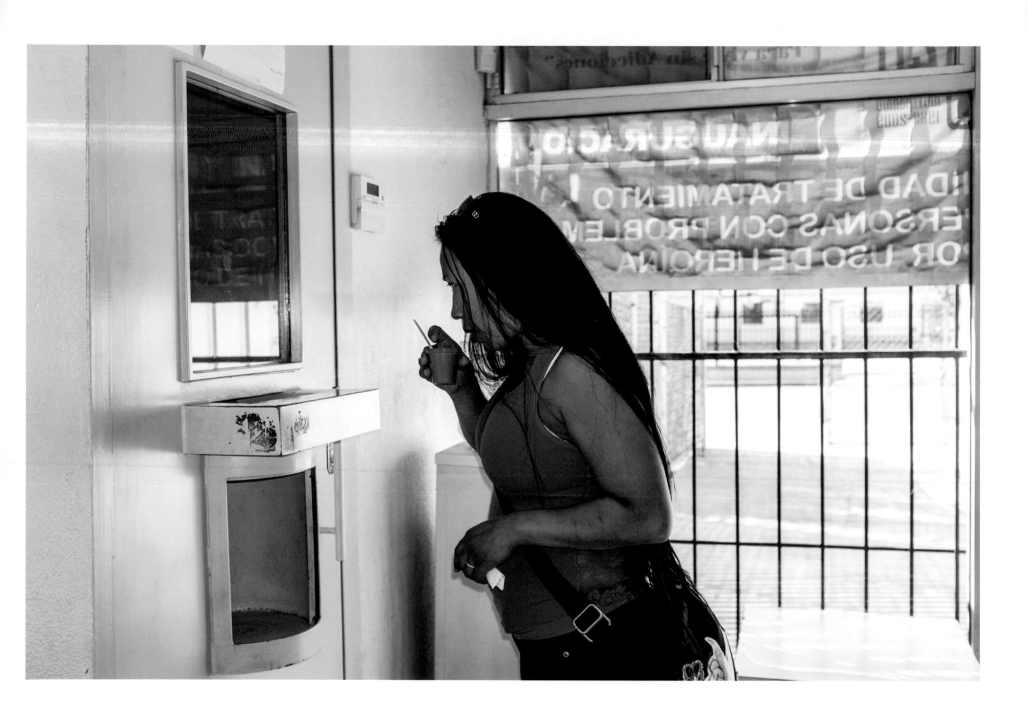

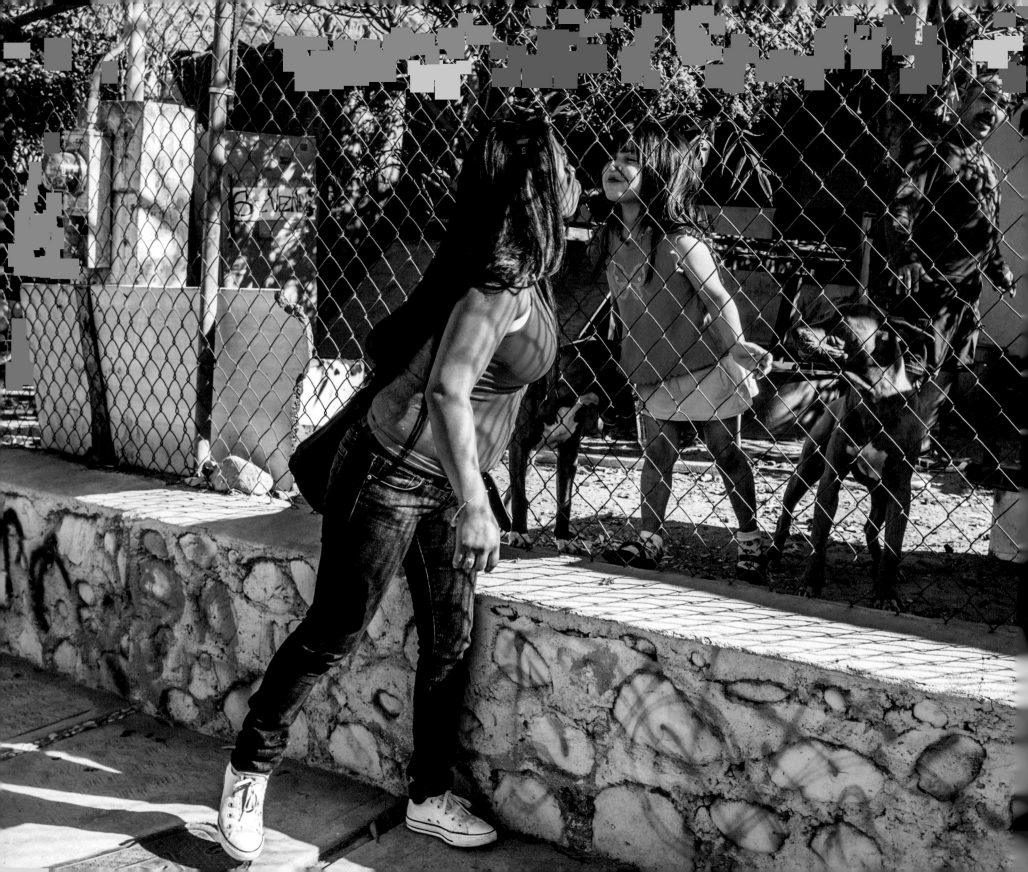

When Ericka was 15, she came to Tijuana with her grandmother from a town near Mexico City. Ericka married a heroin addict and had a son with him. "I started using to try and understand why it was so difficult for him to stop," she said. She was 22. Her husband soon started pimping her. "I was afraid and knew that if I didn't take money home, he'd beat me up." He died of an untreated abscess that led to an infection in his lungs. "I didn't even know how to inject myself when he died," she said.

Ericka was selling caramel lollipops on the street when she met Manuel Ayala Alvarez, a U.S. citizen living in Tijuana. They began a relationship, and he also showed serious interest in her two children, who in 2014 were five and 13. "Other people wanted sex, sex, sex," she said. "Everything that's happened to me makes it very hard for me to trust other people." She ended up marrying Manuel and moving into his house with Saray (pronounced sah-rye-EE) her youngest. He paid for Ericka to start methadone treatment. "Manuel helped me to come back to life again, because I was dying."

On January 25, 2014, five days after Ericka kissed Saray through the fence, four men wearing black headbands walked into the yard, shot one of the family's pit bulls, then beat up Manuel and shot him in the thigh. They were looking for Ericka and Saray, who were out selling lollipops.

Earlier that day, Ericka had had a spat with an ex-girlfriend of Manuel's who lived down the street. The ex started to smack Ericka, and Manuel broke it up. One of the men who attacked Manuel mentioned his ex-girlfriend's name.

At Tijuana General, the doctors told Ericka that Manuel had lost four liters of blood. He spent several days unconscious in the intensive care unit.

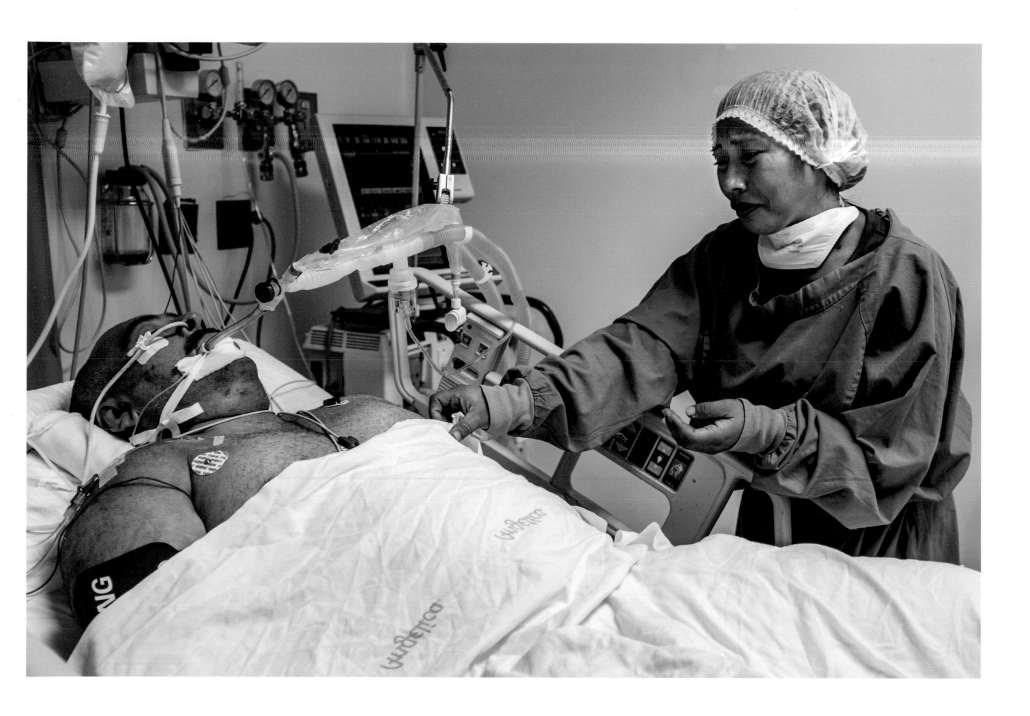

"I've been asking her to see the receipts for her methadone, but she won't give them to me."

The damage to Manuel's leg required a complicated operation, and he decided to have it done in San Diego. Even though they were married, Ericka did not have a visa to go to the United States with her daughter and had to say goodbye to him at the border.

Manuel's leg became infected with drug-resistant bacteria, complicating his recovery and prolonging his absence. Without him Ericka had trouble staying off heroin. "When I was gone, she relapsed," said Manuel in September 2014. "I've been asking her to see the receipts for her methadone, but she won't give them to me. So I stopped funding her. I'm not going to be a codependent."

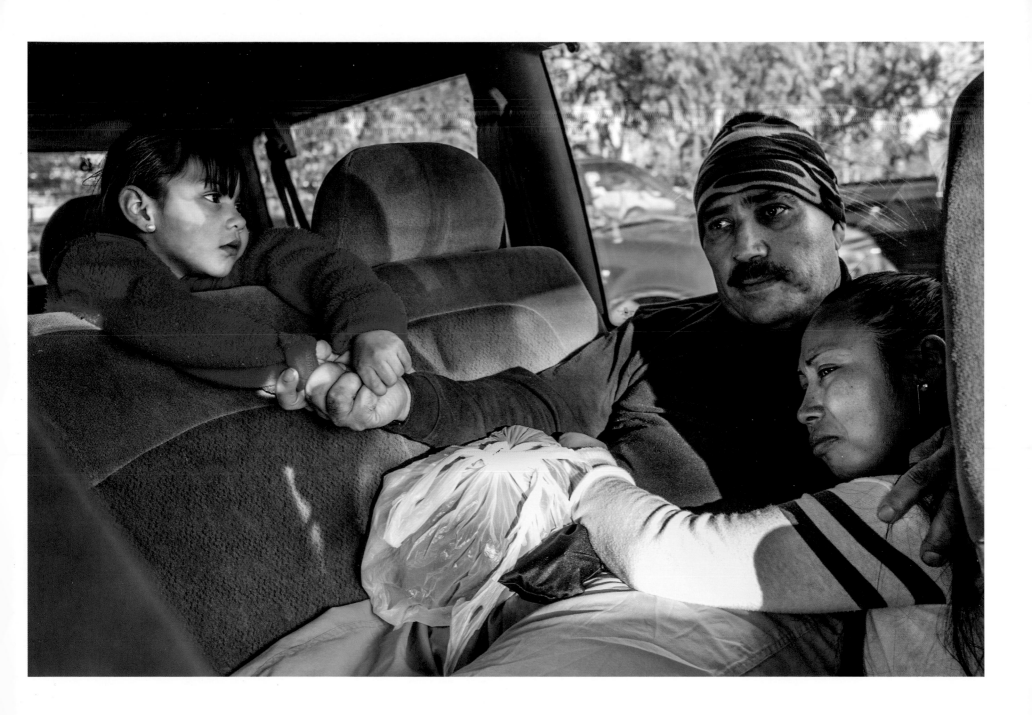

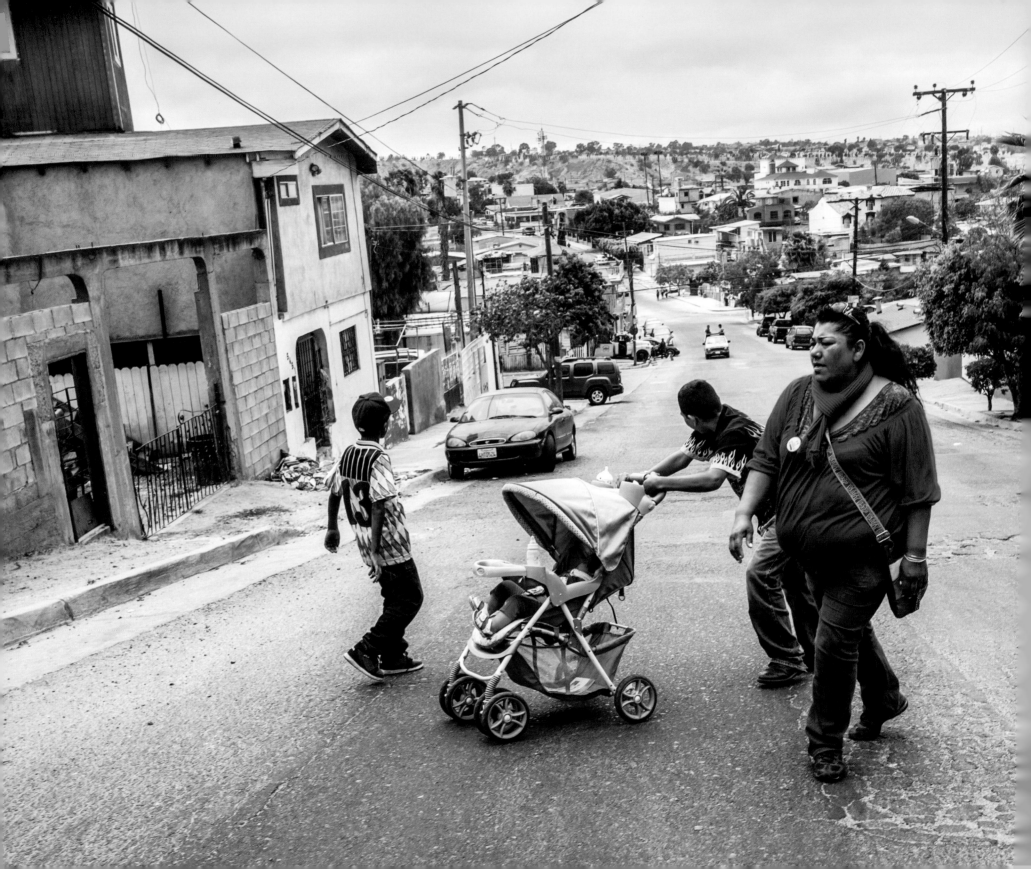

*"I thought at that moment my life wouldn't
make any sense again."*

Lily Ayala learned that she was infected with HIV in 2004 when she gave birth at Tijuana General Hospital. "A nurse said I was going to die from AIDS," recalled Lily, 40. "I thought at that moment my life wouldn't make any sense again." Her baby boy, it turned out, was infected, too. "For several months, instead of searching for professional help, I focused on using drugs."

Lily's crystal meth addiction led to her son being put in foster care when he was six months old. She eventually found religion and stopped using meth. Lily regained custody of her son (striped shirt) when he was three. Both went on antiretrovirals and the HIV levels in their blood became undetectable.

Es Por Los Niños, a nonprofit in Tijuana that provides education and psychological support to families living with HIV, assisted Lily through her crisis and continues to help her navigate the medical system. Rosalva Vásquez, a Tijuana native who had moved to San Diego, started the group in 2010, a year after her own son died of AIDS.

155

Lily was one of 62 HIV-infected women who gave birth at Tijuana General Hospital during the years 2003 through 2005. A study done by doctors from the hospital and their collaborators at UCSD found that only 18 knew their HIV status before they entered the hospital; Lily and 44 of the others were diagnosed in the labor and delivery unit.

If an HIV-infected mother receives no treatment, she transmits the virus during birth about one out of four times. (Breast-feeding can later infect a baby.) Treating the mother in labor and the baby at birth with a single antiretroviral drug cuts that transmission rate in half. Combinations of antiretroviral drugs given to the mother early in the pregnancy reduce transmission to around 1%. The study done at Tijuana General found that two-thirds of the mothers diagnosed in labor did not receive any antiretrovirals. Ten mothers, Lily included, transmitted the virus to their babies. In contrast, UCSD's hospital has not had a transmission from mother to child since 1994.

In 2013, Lily gave birth to a baby girl who did not become infected with HIV. The HIV/AIDS clinic at Tijuana General is primarily for children, but *Es Por Los Niños* convinced the program to allow their mothers and siblings to be seen there, too, so they do not have to make the long trip to CAPASITS. Early one morning, Lily and a boyfriend's son walked to the hospital to get shots for the baby. "I'm a very happy person," Lily said. "I don't think about the past. Everything is new now."

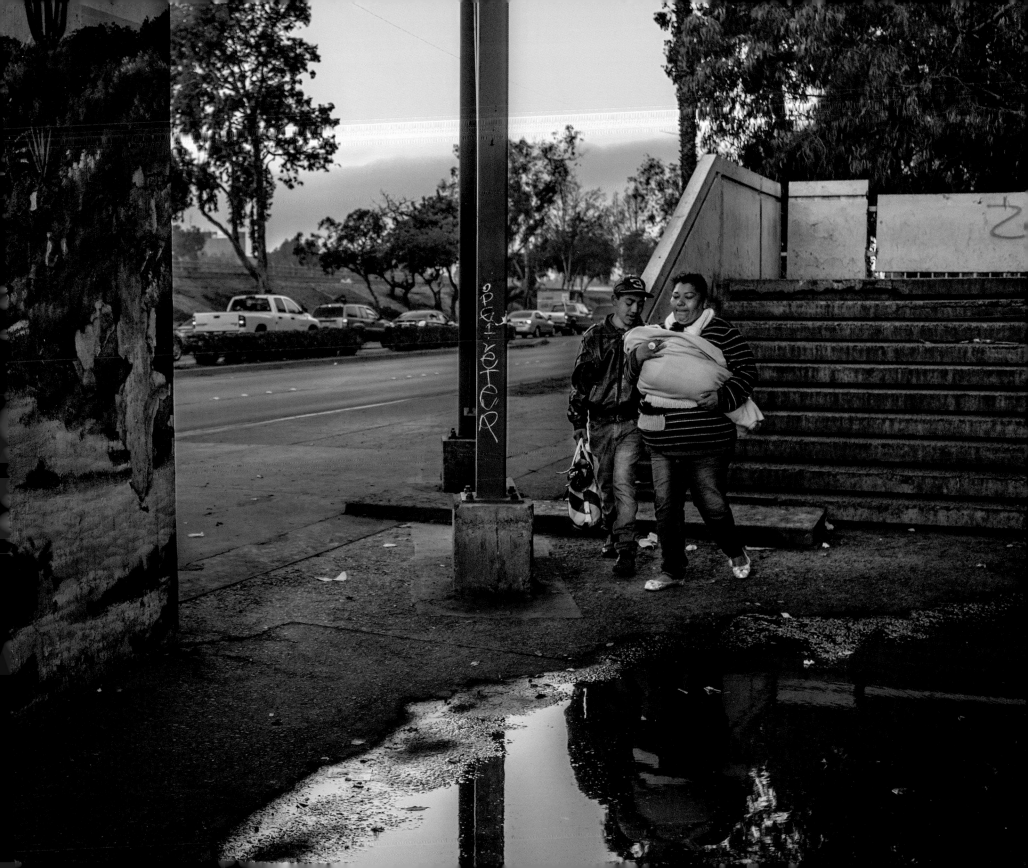

"For one year, I was always passed out."

Sergio González, a Tijuana native, was deported from San Diego in 1994, but he speaks fluent English and continued to cross the border pretty much at will. "Before September 11, it was easy," said Sergio. "I'd say, U.S. citizen, born at Mercy Hospital."

Sergio was a carpenter by trade and also worked as a waiter on Revolución Avenue, but his life fell apart because of crystal meth and heroin. In 2002, he lived in a *ñongo* in El Bordo. "For one year, I was always passed out."

He joined El Cuete and learned he was infected with HIV. His wife, Araceli Contreras, was infected, too, as was their five-year-old son, Eduardo. At the start of 2014 the family was living at Las Memorias.

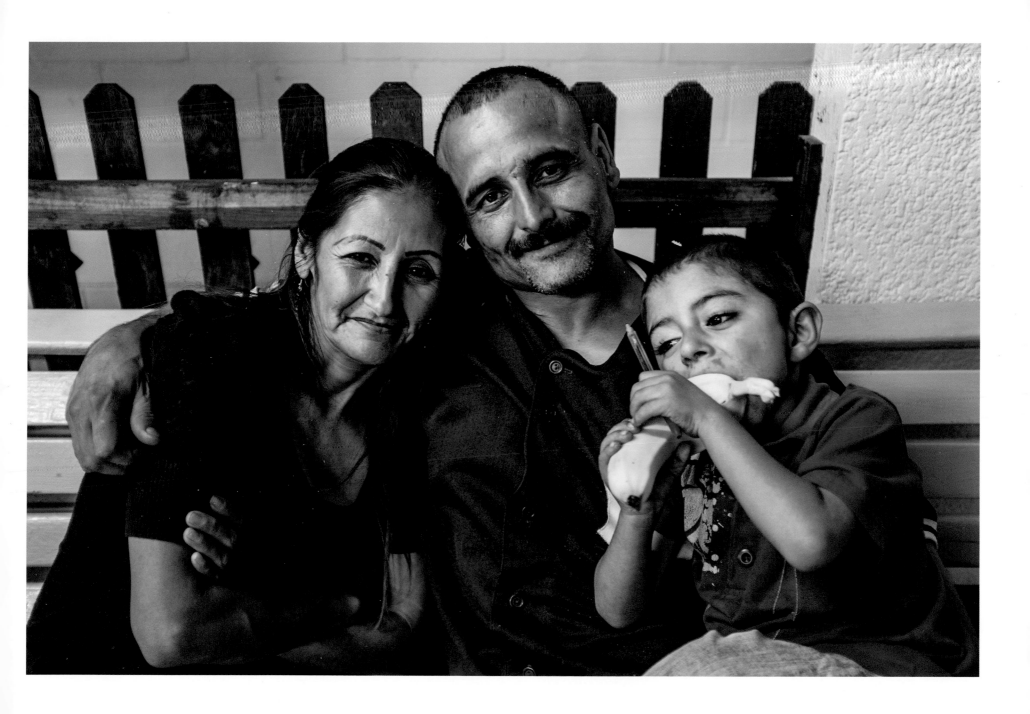

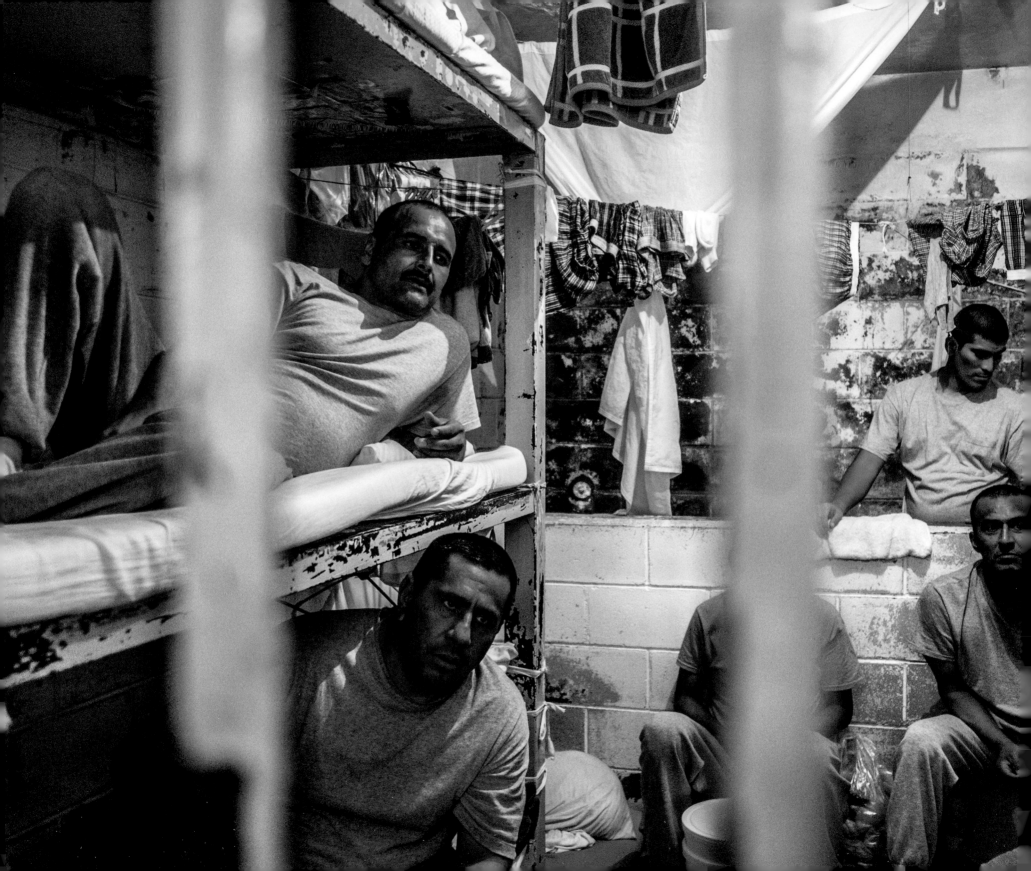

On February 27, 2014, Sergio was jailed in Tijuana's La Mesa prison for holding more crystal than legally allowed.

He called Araceli regularly. "She was alone with the kid and it was diffi-cult for her," he said. "I felt terrible." She also stopped responding to her antiretrovirals, probably because she had developed resistance and did not change drugs. That August she died. Sergio was not allowed to attend her funeral.

Eduardo was made a ward of the state and placed in a Tijuana orphanage, EUNIME. It cares for two dozen children whose parents have died of AIDS or are HIV-infected and alive but have substance abuse problems. Some of the children have HIV themselves. Sergio hoped that when he was released from prison he could regain custody of his son and move back into Las Memorias.

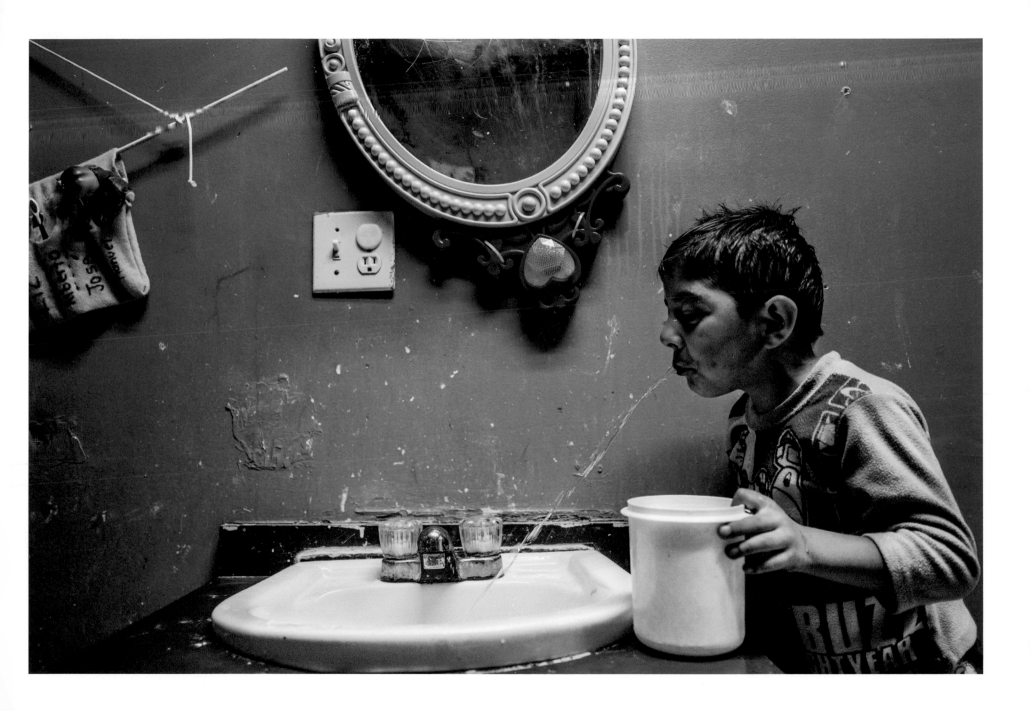

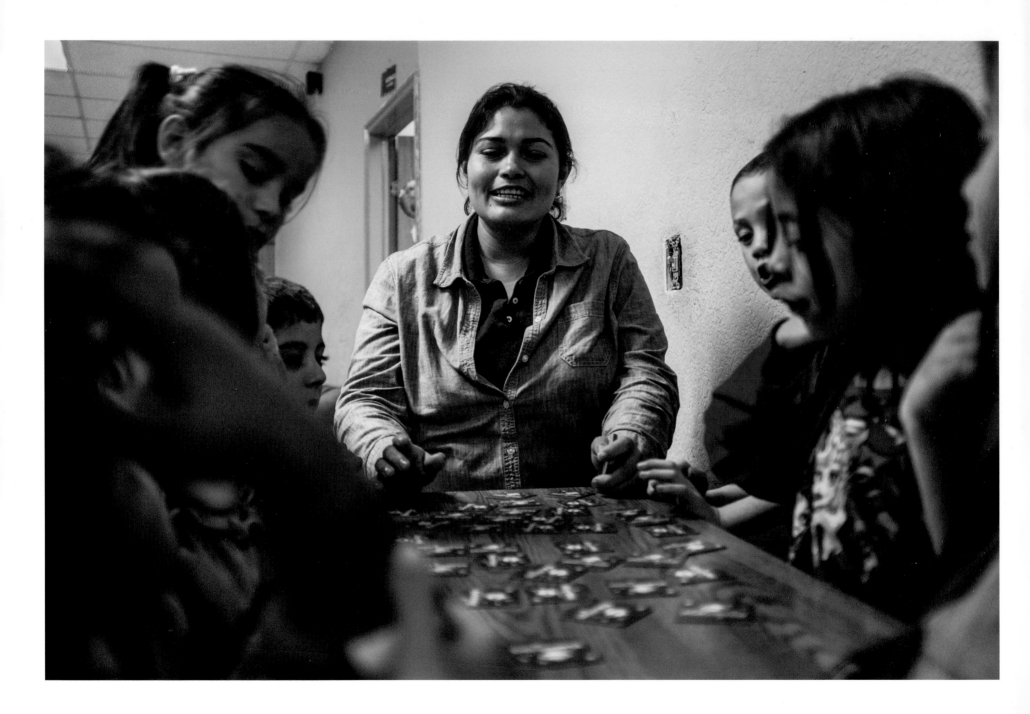

"Everyone was looking at us like, Where the hell did they come from? They were looking at us even worse when we asked for HIV tests."

EUNIME is named after two HIV-infected sisters, Eunice and Noemí. Juanita Ortiz, an uninfected sister, cofounded the orphanage with Rosalva Vásquez, who later started *Es Por Los Niños* after the two had a falling-out. Although Juanita was raising two children of her own, her life revolved around EUNIME.

Juanita moved from Michoacán state to Tijuana with her father when she was 12. Three years later, in 1995, she learned that her mother, who was back in Michoacán with a new husband, had died of AIDS. Eight of her siblings were living with her mother, and Juanita's older brother decided that they all should come live with him in Tijuana.

Juanita had a place of her own and was working two jobs in addition to going to school. When the children arrived, she was recruited to help care for them. "That was a big adventure," she said. They had bloated bellies from malnourishment, and parasites coming out of their noses and mouths; Eunice, who was six months old, had a fungus on her neck and a swollen liver. Juanita took all eight of them to the health department for HIV tests. "Everyone was looking at us like, Where the hell did they come from? They were looking at us even worse when we asked for HIV tests."

Juanita's mother was infected by her second husband, and Juanita was not surprised that Eunice, the youngest, was infected as well—but she was startled to learn that Noemí, who was seven, tested positive, too. Noemí and Juanita had the same father—their mother's first husband, who wasn't infected with HIV—so it did not make sense. Then Juanita remembered that as a child, she once saw her stepfather and Noemí naked together. "I didn't understand what sex was, but I knew it was wrong," she remembered. "It was grotesque." Noemí later confirmed to Juanita that the abuse had gone on for years.

A nun working with terminally ill children heard about the sisters in 1998 and came to the door of the house to ask if they wanted to join a treatment program at UCSD. "It was a gift from God," said Juanita. Eunice was too far along for the antiretrovirals to rescue her, and she died the next year. But Noemí thrived.

When adolescence kicked in, Noemí decided she did not want to take her medicine any more. "She said, 'Well, everybody tells me I'm going to die anyway,' " recalled Juanita. Noemí developed TB, went into a coma, and received her last rites. But she restarted antiretrovirals and recovered. Noemí tragically ended up marrying a man who convinced her that HIV did not cause AIDS and again she stopped taking her antiretrovirals. She died of AIDS in January 2014.

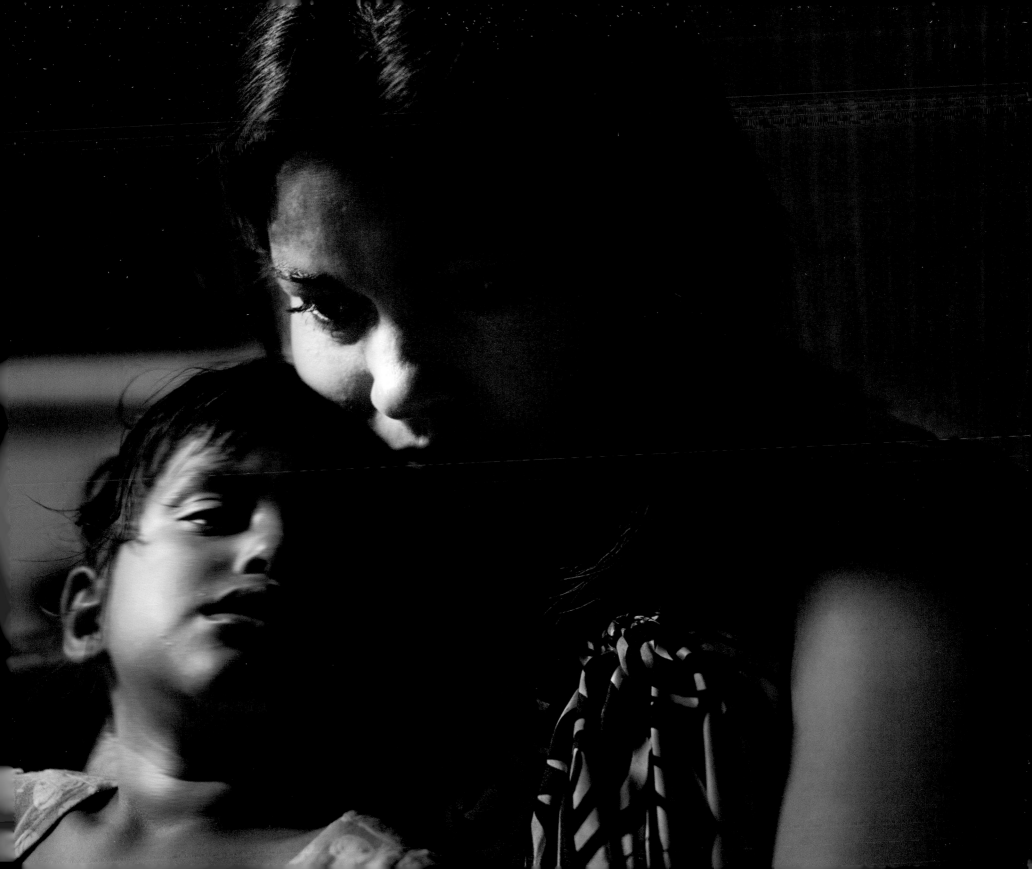

El Bordo, for all its faults, was a community. Some people even celebrated public holidays like Halloween.

In March 2015, the mayor of Tijuana began the most aggressive campaign ever launched to "clean" the canal. More than 500 residents were moved into rehab centers, and others were shipped to their home states. Some began sleeping on the streets. Police set up a 24/7 patrol of the canal to make sure no one returned.

Dr. Patricia González stopped her Friday clinics. "They swept the people away like cockroaches," she said. "The people making these decisions don't have the skills or resources to treat people who are using heroin, and the rehab centers are not prepared. There is no long-term objective whatsoever."

ACKNOWLEDGMENTS

This book would not exist without the extensive cooperation of the people whose stories and images appear on these pages. We deeply appreciate their help—and their willingness to show others their lives. They generously allowed us to observe them up close and spent as much time as we requested discussing their pasts, their current situations, and their perspectives about the future. The researchers, clinicians, and outreach workers in the book similarly deserve special thanks. And the same gratitude extends to the dozens of people at risk of HIV or living with the virus who do not appear here and also allowed us to interview and photograph them for the project. Their stories are equally compelling and important, but of course our space was limited.

The seed for this book was a story we did for *Science* magazine about the research led by Tom Patterson and Steffanie Strathdee of the University of California at San Diego (UCSD). Patterson, Strathdee, and the binational team they have built—with support primarily from the U.S. National Institutes of Health—introduced us to many people, places, and issues, and we cannot thank them enough. Aside from encouraging us from the start, Patterson and Strathdee allowed us to subject them to an endless barrage of questions about their research. In Tijuana, Susi Leal in particular went out of her way to teach us the lay of the land, and she was a wildly entertaining, bold, and street-smart professor. Patricia González kindly opened many doors, let us tag along at her canal clinics, repeatedly tracked down critical information we needed, and kept us abreast of local politics.

José Luis Burgos warmly invited us to observe his Prevencasa Saturday clinics with medical students. Thanks to the staff at El Cuete, which did us many favors large and small, and also welcomed Malcolm Linton, a registered nurse, as a volunteer for a few months. Other UCSD researchers who assisted us along the way include Rolando Viani, Victoria Ojeda, Richard Garfein, Davey Smith, Susan Little, and Jaime Arredondo.

The staff and residents at Las Memorias made us feel at home there, and we especially want to tip our hats to its dedicated director, Antonio Granillo, and his most capable right-hand man, Sergio Borrego. Juanita Ortiz always had time for us at EUNIME. At SER, Kristian Salas and Rosario Padilla were especially helpful and made our visits to La Mesa Prison possible. Many thanks to Prevencasa's Rebeca Cázares, Luis Segovia, and the rest of the staff. At Tijuana General Hospital, doctors who helped included Samuel Navarro, Rafael Laniado and Graciano López. Mario Lam and Manuel Gallardo met with us at CAPASITS. Rosalva Vásquez with *Es Por Los Niños* introduced us to several people her group assists. Others in Tijuana whom we learned from and thank: Victor Clark, Remedios Lozada, and Omar Olivarría. Rubi Juárez, Salvador Rodríguez, Angela Placencia, and José Alberto Ferezi helped with everything from translations to finding people and arranging interviews. David Kussin gave valuable legal advice when we were drafting our consent form.

In San Diego, we much appreciate the assistance we received from Walgreens Pharmacy's Franko Guillén, Christie's Place, the San Ysidro

Health Center, UCSD's Lead the Way program, and Richard Kiy from the International Community Foundation.

Many funders made it possible for us to conduct 20 months of fieldwork and publish this book, and we wish to express a most profound gratitude to each one. First and foremost, the Ford Foundation's Mexico and Central America office provided the initial funding and the bulk of our support; Mario Bronfman was a driving force for this project becoming a reality, and Ana Luisa Lugori saw it across the finish line.

The following people and their foundations awarded us grants to offset publication costs: David Gold and Victor Zonana at Global Health Strategies, John Evans at the John D. Evans Foundation, and Daniel Wolfe at the Open Society Foundations. A grant from the Pulitzer Center on Crisis Reporting allowed us to extend our field reporting. And we are most grateful to Colleen Struss, Lori Holland, and Alan Leshner at the American Association for the Advancement of Science (publisher of *Science*), which allowed us to connect this project to our work for the magazine. Jon Cohen's editors at *Science*—in particular, Leslie Roberts, Tim Appenzeller, and Colin Norman— also offered critical support.

Selecting and sequencing the photos that appear here benefited tremendously from the advice of several people, including Yukiko Launois, Abe Ordover, Laurie Kratochvil, Sonja Lashua, Robert Wallis, and Jennifer Wallace.

Others who helped Malcolm Linton along the way include Andy Bowley, Peter Nichols, James Attlee, Anthony Suau, Stephen Ferry, Jane Gittings, François Robert, Timothy Ross, and JP Pappis. Special recognition goes to Richard Trauger, who reviewed the images repeatedly and provided a second home for Linton in San Diego.

Warm thanks go to a number of people who helped achieve optimal color correction and printing: in New York, Chuck Bogana at ColorOne Inc.; and in Bogota, Colombia, Jesús Alberto Galindo and Marta Mendez at Alma Digital SAS, and the staff of Panamericana Formas e Impresos S.A., especially Ruth Ojeda, Hermes Muñoz, and William Rodriguez.

A big thank you to Shannon Bradley (Jon Cohen's wife) for all her support, suggestions, and editing help. Martin Enserink graciously gave the final draft a close edit, as did Erin Cohen. And muchas gracias to Jennifer Therieau of Cool Grey Matter for creating the book's website, and to Pascal Gagneux for drawing us a map of Tijuana with the locations described here. We are much obliged to Michael Itkoff and Taj Forer at Daylight for taking on this project, and to our designer, Ursula Damm. Finally we thank copy editor Elizabeth Bell.

Malcolm Linton is a British-born photojournalist who has lived and worked in Latin America, Russia, Africa and Asia. His photos have appeared in magazines and newspapers worldwide and frequently focus on conflict and human rights issues.

Jon Cohen is a writer based near San Diego, California, who has covered HIV/AIDS for *Science* since 1990. He has written for many other magazines on a wide variety of topics and published three books, including *Shots in the Dark: The Wayward Search for an AIDS Vaccine* (New York: W.W. Norton, 2001).